REMINGTON & RUSSELL

ARTISTS OF THE WEST

William C. Ketchum, Jr.

SMITHMARK

This edition published in 1997 by
SMITHMARK Publishers,
a division of U.S. Media Holdings, Inc.,
16 East 32nd Street, New York, NY 10016.

SMITHMARK books are available for bulk
purchase for sales promotion and premium use.
For details write or call the manager of special sales,
SMITHMARK Publishers,
16 East 32nd Street, New York, NY 10016;
(212) 532-6600.

This book was designed and produced by
Todtri Productions Limited
P.O. Box 572, New York, NY 10116-0572
FAX: (212) 279-1241

Printed and bound in Singapore

Library of Congress Catalog Card Number 96-71464

ISBN 0-7651-9486-4

Author: William C. Ketchum, Jr.

Publisher: Robert M. Tod
Editorial Director: Elizabeth Loonan
Book Designer: Mark Weinberg
Senior Editor: Cynthia Sternau
Project Editor: Ann Kirby
Photo Editor: Edward Douglas
Picture Reseachers: Heather Weigel, Laura Wyss
Production Coordinator: Annie Kaufmann
Desktop Associate: Paul Kachur
Typesetting: Command-O

Picture Credits

Amon Carter Museum, Fort Worth, Texas 4–5, 46–47, 52–53, 60, 67, 71, 76–77, 78, 79, 82, 83, 84, 85, 102, 111, 114, 115, 117, 123

The Anschutz Collection, Denver, Colorado 75, 103, 107

Buffalo Bill Historical Center, Cody, Wyoming 32–33, 44, 61–62, 65, 66–67, 68, 93, 95, 108, 113, 116, 119

Duquesne Club, Pittsburgh, Pennsylvania 6, 28–29

The Thomas Gilcrease Institute of American History and Art, Tulsa, Oklahoma 122

The Metropolitan Museum of Art, New York 62–63

Montana Historical Society, Helena, Montana 7, 14–15, 17, 18, 22–23, 24–25, 70, 100–101

Museum of Fine Arts, Houston, Texas 40–41, 58, 97

National Museum of American Art, Washington, D.C.—Art Resource, New York 96

R. W. Norton Art Gallery, Shreveport, Louisiana 10

Remington Art Museum, Ogdenburg, New York 11, 13, 38, 49, 50, 51, 54, 64, 80, 94, 99, 120–121, 126

C. M. Russell Museum, Great Falls, Montana 12, 31, 34, 35, 36, 104–105, 110, 118, 124, 125, 127

Sid Richardson Collection of Western Art, Fort Worth, Texas 8–9, 19, 20, 21, 26, 27, 30, 37, 43, 55, 72–73, 81, 86–87, 88–89, 90–91, 92–93, 98

Sterling and Francine Clark Art Institute, Williamstown, Massachusetts 56–57, 106

Toledo Museum of Art, Toledo, Ohio 48

The Wichita Art Museum, Wichita, Kansas 74

Yale University Art Gallery, New Haven, Connecticut 59

CONTENTS

Introduction

Frederic Remington and Charles Marion Russell are regarded as the most important illustrators of the American West, their paintings and sculpture capturing the essence of the nation's frontier life in the nineteenth century. Yet both worked at a time when much of what was regarded as the West was already gone and the rest vanishing rapidly.

Russell reached Montana in 1880; Remington paid his first visit West a year later. By this time the fur harvests were forty years in the past, the gold rush of '49 was petering out, and the Indian wars were over, with the Montana tribes largely confined to reservations. By 1882 the last of the northern buffalo herd was gone, and transcontinental rail lines were disgorging hordes of farmers and tradesmen whose goal was to make the territory west of the Mississippi as much like their former homes as possible.

But these two artists' chief subjects—the cowboy for Russell and, for Remington, the cavalry trooper—were there as yet, to be studied, observed, and, as the task they would set for themselves, rendered well for posterity.

Parallel Lives?

In examining the life stories of Frederic Remington and Charles Russell, one is immediately struck by remarkable similarities. Both men were born of well-to-do families. Both rejected school and the

The Smoke Signal

FREDERIC REMINGTON

1909, oil on canvas. Amon Carter Museum, Fort Worth, Texas.

In 1961 this painting was chosen to adorn a stamp issued to commemorate the one hundredth anniversary of Remington's birth. Though other paintings (including works by Russell) had been reproduced on stamps, this was the first in full color.

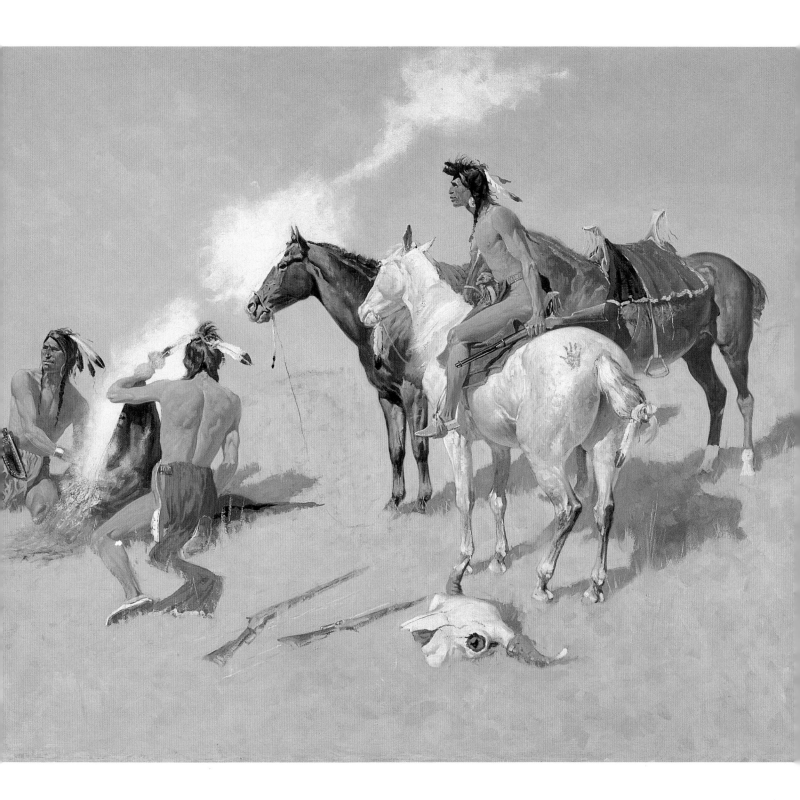

business world in favor of art, to which they were drawn at an early age, yet neither could long abide formal art education.

Both "went West," and both ended up initially herding sheep, an occupation they jointly loathed. Each established a lifelong relationship with a spouse upon whom they became highly dependent, but neither had children (though the Russells did adopt). Neither cared for automobiles, and neither learned to drive. Each painter had a woodland retreat to which he would withdraw periodically to work and rest. Both were drinkers; both suffered attacks of appendicitis.

Each artist first established himself as an illustrator, later gaining a reputation as a sculptor, writer, and easel painter. Neither, however, was ever accepted by the art establishment though they were loved by the general public and revered by the media, which relied upon them to depict the ever-popular West as it once was.

Divergent Paths

Still, the differences between the two men are equally striking. Charlie Russell lived his life in the West, worked for over a decade as a cowboy, knew Native Americans as

Russell and Albert Trigg in Camp

UNKNOWN PHOTOGRAPHER

n.d., black-and-white photograph.

Montana Historical Society, Helena, Montana.

Trigg, a Great Falls businessman, was one of Russell's earliest supporters and closest friends. They are seen here on a camping and fishing trip.

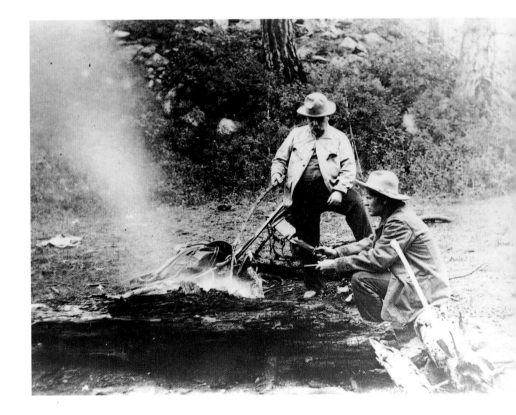

When Ignorance is Bliss (The Unexpected Guest)

CHARLES M. RUSSELL

1916, watercolor on paper. Duquesne Club, Pittsburgh, Pennsylvania.

Well known for portraying the drama of Western life, Russell also had a humorous side, as seen in this painting. We can only hope that the blissful one's partner was a sure shot!

FOLLOWING PAGE:

Three Generations

CHARLES M. RUSSELL

1897, oil on canvas. Sid Richardson Collection of Western Art, Fort Worth, Texas.

Russell knew and admired Native Americans, and this touching scene is one of the most sympathetic renderings of tribal life to come out of the Western artistic tradition.

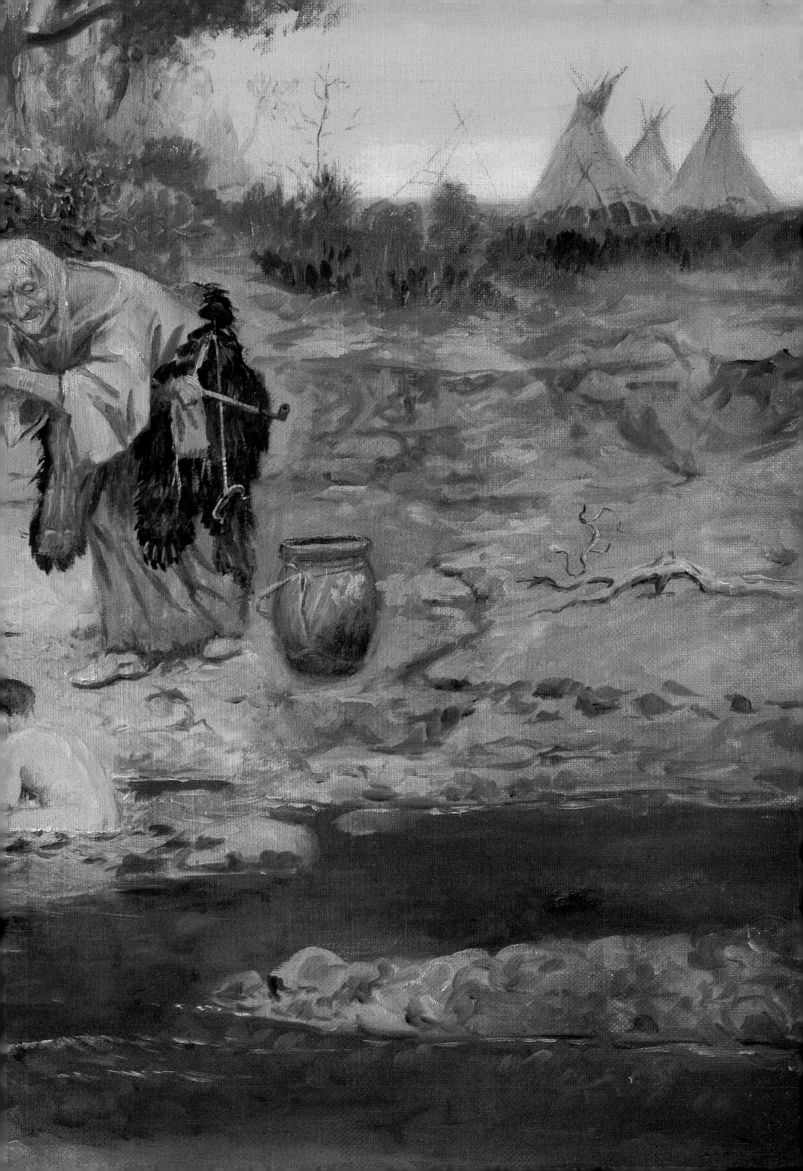

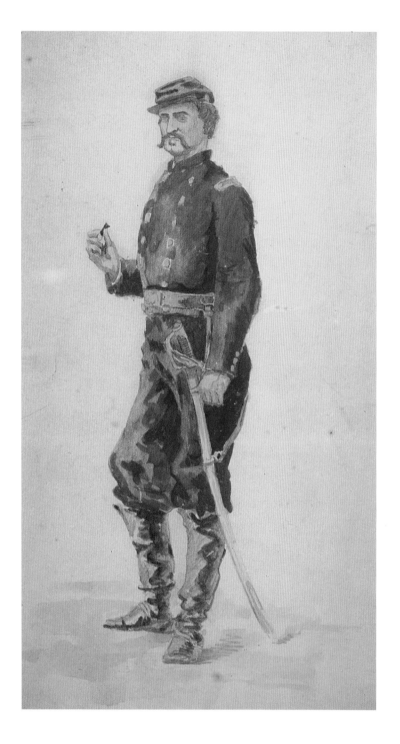

Seth Remington

FREDERIC REMINGTON

late 1870s, watercolor. R. W. Norton Art Gallery, Shreveport, Louisiana.
The senior Remington, a dashing Civil War cavalryman,
was Frederic's idol. His life offers, in part, an explanation
for the artist's fondness for depictions of horse soldiers.

friends, and had many opportunities to observe intimately western wildlife. Frederic Remington spent just a few months on a Kansas sheep ranch, then made periodic trips West, usually accompanied by members of the United States military whose viewpoint of the "Indian question" he generally embraced.

Russell was always a country boy, uncomfortable in the East, particularly in New York City. Remington lived his life in and around the metropolis, and cultivated an upper-class lifestyle. Where Russell mostly stayed at home, Remington roamed the world—Cuba, Mexico, Russia, England—seeking adventure and subject material for his work.

Russell appears to have been an unusually tolerant (particularly for his time) man, rarely having a bad thing to say about anyone. (He was silent on the subject of the military, but the fact that troopers never appear in his work speaks volumes.) Remington, unfortunately, apparently shared some of the worst racist views of his contemporaries. He appears to have not cared for Indians, Mexicans, Orientals, and blacks (making a tentative exception for the Negro Cavalry or "Black Buffaloes"). He also was frequently at odds with the Eastern artistic establishment and battled regularly with publishers, editors, reviewers, and collaborators.

Though a drinker in his youth, Russell, under his wife's influence, quickly learned to moderate his intake of alcohol, where Remington by his own admission was a glutton who ate and drank to excess and the detriment of his health. Charlie survived his appendectomy. Frederic died of peritonitis.

Russell was by his friends' testimony a "straight shooter" whose word was his bond. Remington was known to be a frequent liar, a teller of tall tales regarding his own background to suit his self-image and career. Russell was generous to a fault, giving away his money and art work until reined in

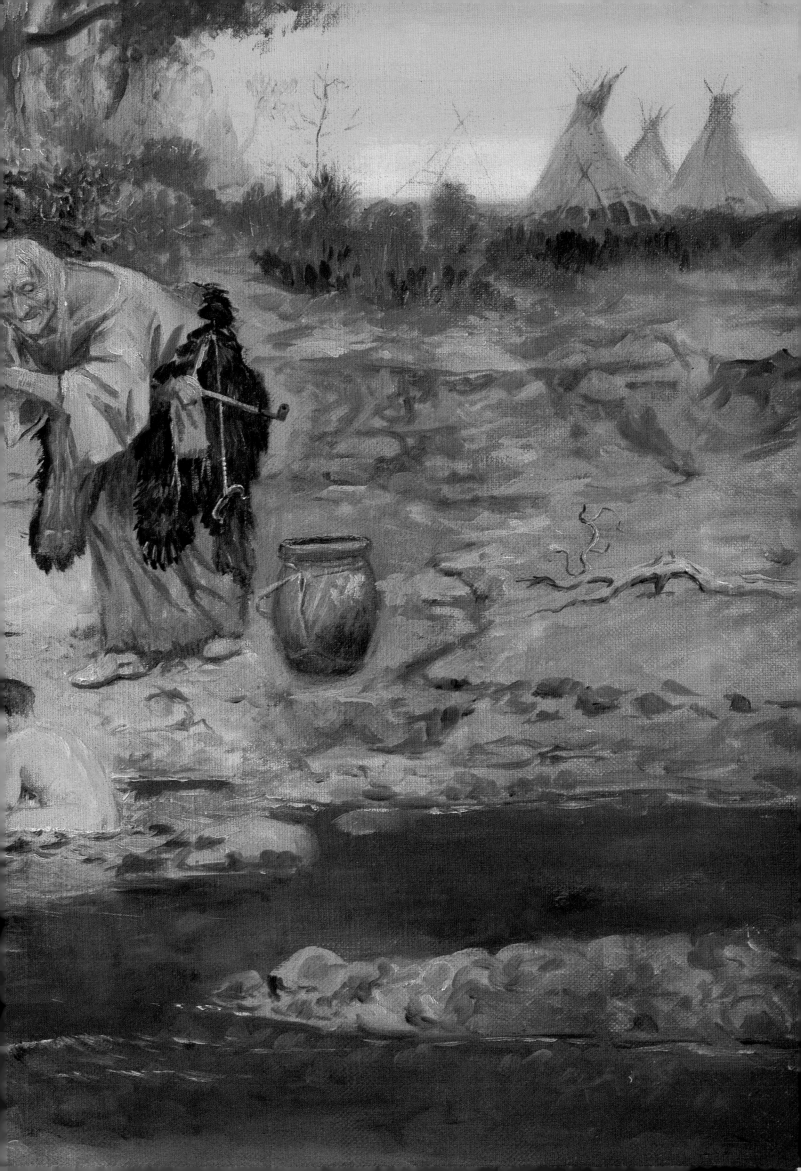

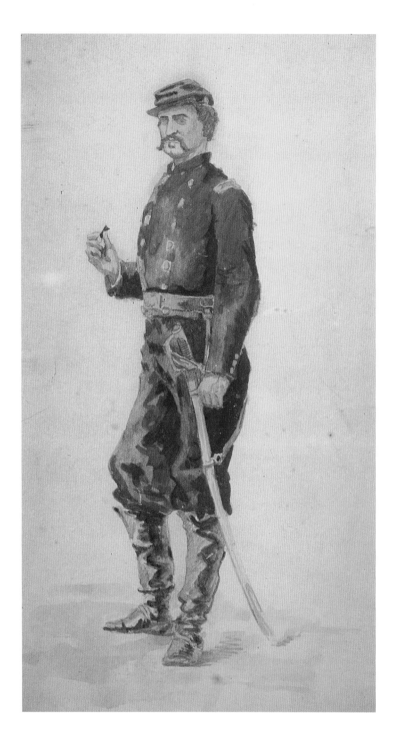

Seth Remington

FREDERIC REMINGTON

late 1870s, watercolor. R. W. Norton Art Gallery, Shreveport, Louisiana.

The senior Remington, a dashing Civil War cavalryman,

was Frederic's idol. His life offers, in part, an explanation

for the artist's fondness for depictions of horse soldiers.

friends, and had many opportunities to observe intimately western wildlife. Frederic Remington spent just a few months on a Kansas sheep ranch, then made periodic trips West, usually accompanied by members of the United States military whose viewpoint of the "Indian question" he generally embraced.

Russell was always a country boy, uncomfortable in the East, particularly in New York City. Remington lived his life in and around the metropolis, and cultivated an upper-class lifestyle. Where Russell mostly stayed at home, Remington roamed the world—Cuba, Mexico, Russia, England—seeking adventure and subject material for his work.

Russell appears to have been an unusually tolerant (particularly for his time) man, rarely having a bad thing to say about anyone. (He was silent on the subject of the military, but the fact that troopers never appear in his work speaks volumes.) Remington, unfortunately, apparently shared some of the worst racist views of his contemporaries. He appears to have not cared for Indians, Mexicans, Orientals, and blacks (making a tentative exception for the Negro Cavalry or "Black Buffaloes"). He also was frequently at odds with the Eastern artistic establishment and battled regularly with publishers, editors, reviewers, and collaborators.

Though a drinker in his youth, Russell, under his wife's influence, quickly learned to moderate his intake of alcohol, where Remington by his own admission was a glutton who ate and drank to excess and the detriment of his health. Charlie survived his appendectomy. Frederic died of peritonitis.

Russell was by his friends' testimony a "straight shooter" whose word was his bond. Remington was known to be a frequent liar, a teller of tall tales regarding his own background to suit his self-image and career. Russell was generous to a fault, giving away his money and art work until reined in

by his wife. Remington concerned himself much more with profit in order to maintain his affluent existence, be it from marketing his illustrations, paintings, and bronzes, or trying his hand at the stock market.

Charlie's wife, Nancy, played a dominant role in his career, not only encouraging him but also managing his relationships with publications and buyers, asking (and getting) ever higher prices for his work, while at the same time keeping him close to the studio and away from his cronies. Eva Remington, on the other hand, showed less interest in her husband's work. Remington managed his own business while his wife ran the house—a far more typical Victorian-era relationship.

A quick gloss of such information might lead one to believe that all the virtue lay on the side of Charlie Russell, and that Frederic Remington was a real stinker. Naturally, there is more to the story. Russell was a pretty simple character. He had a major gift for painting and sculpture and a minor one for writing. Remington was a much more complex personality, a genius whose wild mix of talents led him into painting and sculpture; the writing of novels, short stories, and a stage play; life as a war correspondent; the invention of military gear; even suggestions for the reorganization of the U.S. Army. You might say Russell was the proverbial big frog in a little (albeit legendary) pond; Remington, though, always played "the big game" for the highest stakes.

Together they comprise the intriguing, contradictory American character as confined and consumed by "the West"—real and mythic alike.

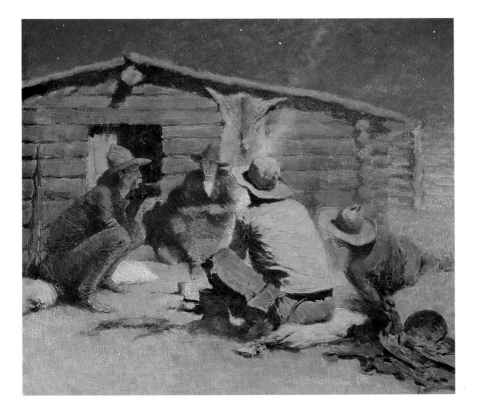

Last Painting (untitled)

FREDERIC REMINGTON

1909, oil on canvas. Remington Art Museum, Ogdensburg, New York. It is fitting that the artist's final work should have combined a Western subject with his then current interest in the impressionistic effects of night light.

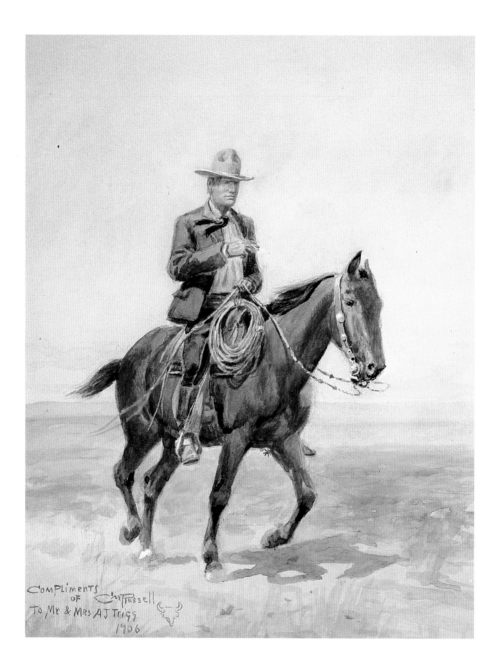

Charles Russell on Neenah

CHARLES M. RUSSELL

1906, watercolor. C. M. Russell Museum, Great Falls, Montana.

A gift to his close friends, the Triggs, this self-portrait on his favorite
horse captures the essence of Charles Russell as a western icon.

by his wife. Remington concerned himself much more with profit in order to maintain his affluent existence, be it from marketing his illustrations, paintings, and bronzes, or trying his hand at the stock market.

Charlie's wife, Nancy, played a dominant role in his career, not only encouraging him but also managing his relationships with publications and buyers, asking (and getting) ever higher prices for his work, while at the same time keeping him close to the studio and away from his cronies. Eva Remington, on the other hand, showed less interest in her husband's work. Remington managed his own business while his wife ran the house—a far more typical Victorian-era relationship.

A quick gloss of such information might lead one to believe that all the virtue lay on the side of Charlie Russell, and that Frederic Remington was a real stinker. Naturally, there is more to the story. Russell was a pretty simple character. He had a major gift for painting and sculpture and a minor one for writing. Remington was a much more complex personality, a genius whose wild mix of talents led him into painting and sculpture; the writing of novels, short stories, and a stage play; life as a war correspondent; the invention of military gear; even suggestions for the reorganization of the U.S. Army. You might say Russell was the proverbial big frog in a little (albeit legendary) pond; Remington, though, always played "the big game" for the highest stakes.

Together they comprise the intriguing, contradictory American character as confined and consumed by "the West"—real and mythic alike.

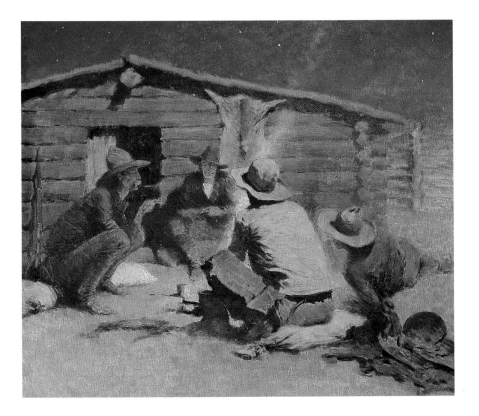

Last Painting (untitled)
FREDERIC REMINGTON
1909, oil on canvas. Remington Art Museum, Ogdensburg, New York.
It is fitting that the artist's final work should have combined a Western subject with his then current interest in the impressionistic effects of night light.

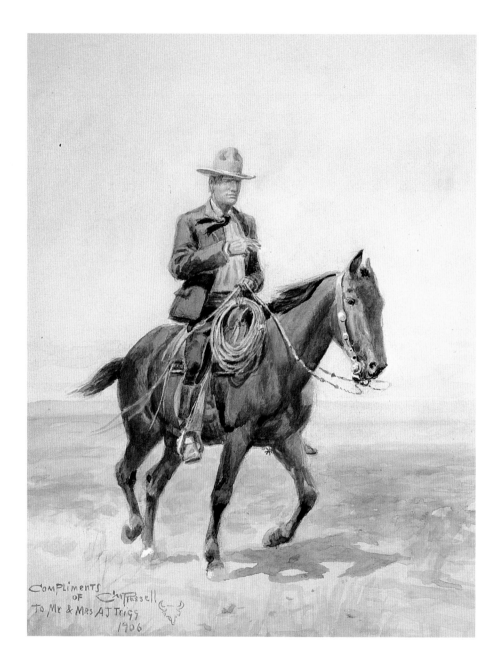

Charles Russell on Neenah

CHARLES M. RUSSELL

1906, watercolor. C. M. Russell Museum, Great Falls, Montana.

A gift to his close friends, the Triggs, this self-portrait on his favorite horse captures the essence of Charles Russell as a western icon.

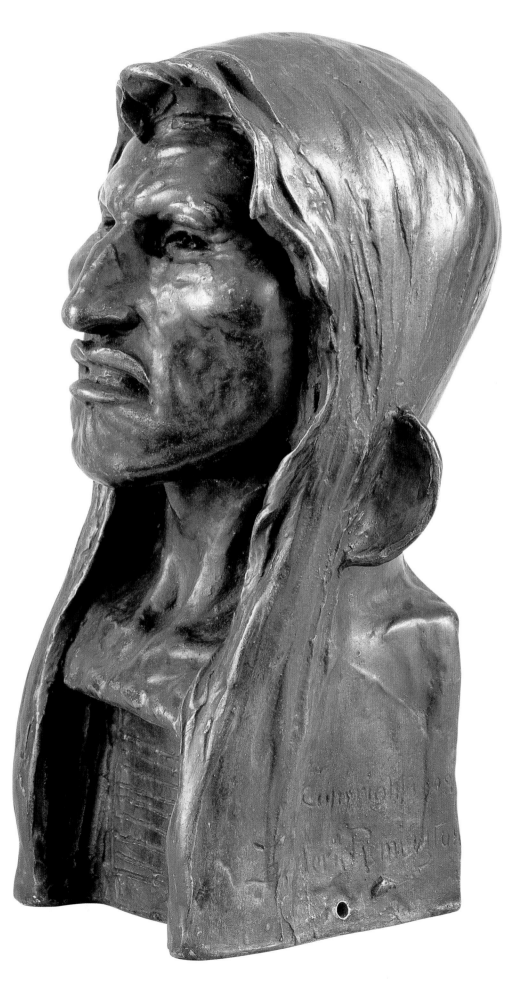

The Savage

FREDERIC REMINGTON

1908, bronze. Remington Art
Museum, Ogdensburg, New York.
In this foot-high sculpture
the artist has personified a
perspective of the Native
American as a violent,
hostile aborigine.

The Herd Quitter

CHARLES M. RUSSELL

1897, oil on canvas, Montana Historical Society, Helena, Montana.

One of Russell's earlier works, this picture depicts that ticklish
moment when a longhorn deserts the herd. It must be brought
back quickly or the whole bunch may follow in a wild stampede.

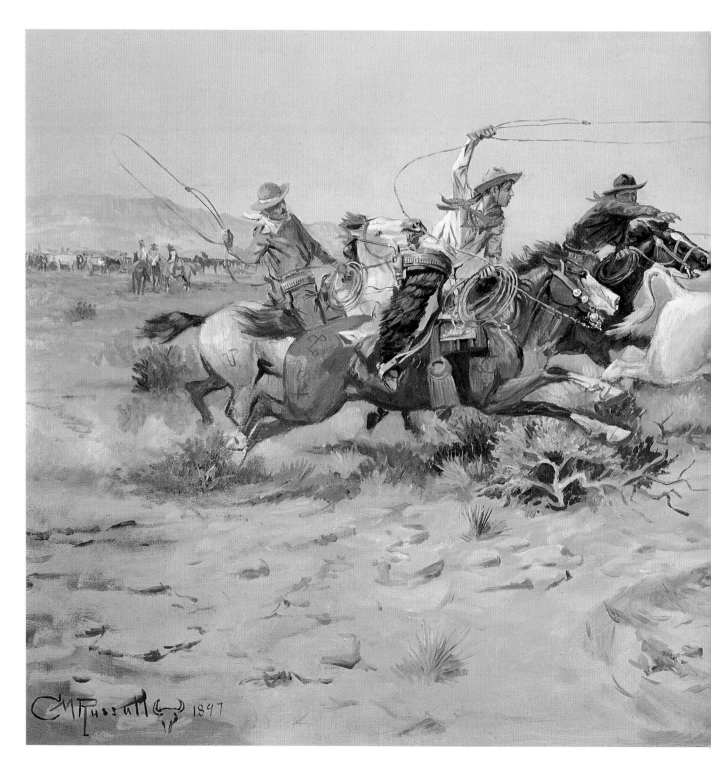

Kid Russell: A Life on the Prairie

If the classic artist's life story is the emergence from poverty to strive for fame and fortune, Charles Marion Russell's life is an exception to this model. Russell was poor only by choice, and he never sought riches or recognition, accepting them grudgingly when they did come to him.

An Affluent Youth

Born in St. Louis, Missouri, on March 19, 1864, Charlie was the third of six children born to Mary Mead and Charles Silas Russell. His father was a partner in the firm of Parker, Russell and Company, then the largest manufacturer of firebrick and associated products west of the Mississippi River. The family was rich and influential, owning a townhouse in St. Louis and a country estate, Oak Hill, not far from the city.

The Russells had early ties to the West. Charlie's great-grandfather Silas Bent had come to St. Louis in 1804, rising to the position of Judge of the Territorial Supreme Court, while his sons, William, George, Charles, and Robert made fortunes in the fur trade; the former would build, in 1828, Bent's Fort on the Arkansas River, the first permanent settlement in what was to become the state of Colorado.

The Bents knew everyone in the early West—Jim Bridger, Bill Williams, and the legendary Kit

The Roundup, No. 2

CHARLES M. RUSSELL

1913, oil on canvas. Montana Historical Society, Helena, Montana.
The roundup of cattle, which had spent the season
feeding on the open plains, was one of the most arduous
and exciting of cowboys' activities. It was also a scene
that Russell knew well from personal experience.

Carson among them. Tales of their exploits were passed down within the family, filling Charlie's mind with dreams of Western adventure. Added to this was the well-known drama of the St. Louis waterfront where, though the fur trade had faded, mountain men, trappers, Western guides, buffalo skinners, and Mississippi River boatmen still told their many tall tales for all to hear.

While the cowboy's life had much appeal for the youth, Charlie was pulled in another direction as well. His mother and an elder brother had shown artistic talent, and this mantle fell upon the young boy. By the time he was six he was sketching and modeling small figures and becoming a careful observer of the natural life about him.

School, on the other hand, had little attraction for the child. Enrolled in one of the city's private academies, he spent his time drawing and playing tricks on his teachers. When academic pressures became too great he would just run away. After several years of this Charles, Sr., despairing of his own disciplinary abilities, sent his son off to military school in New Jersey where, for a semester, Charlie did little but accumulate demerits for a variety of rules infractions. At term's end the boy boarded the western train. He did not return.

Charlie's father loved him, though he did not understand his son's ways. Despite hopes that the boy might succeed to the business, Charles listened when a family friend remarked on his son's incipient artistic abilities. While a private tutor took over the academic studies, Charlie was enrolled in a local art school. He lasted three days, returning home with the complaint that the instructor ". . . don't have time for a kid like me."

Going West

Come what may, young Russell was going West. He knew it; his family knew it. After an abortive attempt, which resulted in only three months

spent working on a farm in central Missouri, Charlie got his chance. In March of 1880, when he was not quite sixteen, his father arranged a trip to Montana with a family friend, Wallis (Pike) Miller, the owner of a ranch in the Judith River Basin.

Central Montana at this time was sparsely settled. Bands of Blackfeet, Crows, and Piegans still roamed the plains, game was plentiful, and the few ranches were set far apart. But the mining industry had started up, communities were building, and ranchers, like Miller, were taking advantage of the lush grasslands.

The problem for Charlie was Pike's animals. Russell had come West to be a cowboy. The firm of Waite & Miller grazed sheep. Assigned to herd them, Charlie soon came to hate them. He spent much of his time sketching and modeling and as little time as he possibly could watching his charges.

It was not long before Charlie and Pike Miller parted company—but not, as his father had hoped, to return to family and career. In June 1880 the growing boy hit the western trail with two horses, a bed roll, and little else. But fate proved kind. The first night out he met Jake Hoover, a well-known hunter and trapper who immediately took Charlie under his wing.

Young Russell spent two years with Hoover roaming far and wide from their cabin on the South Fork of the Judith River. Though he was a market hunter Hoover loved animals, and under his instruction Russell came to understand the habits of the elk, deer, bear, and mountain sheep common to the area. This training plus hours spent on his own observing everything from beaver to bison was, in later years, to result in the remarkable understanding and fidelity to detail with which the artist portrayed wildlife in the West.

With the earnings accumulated through his work with Hoover, Charlie did go back to St. Louis in

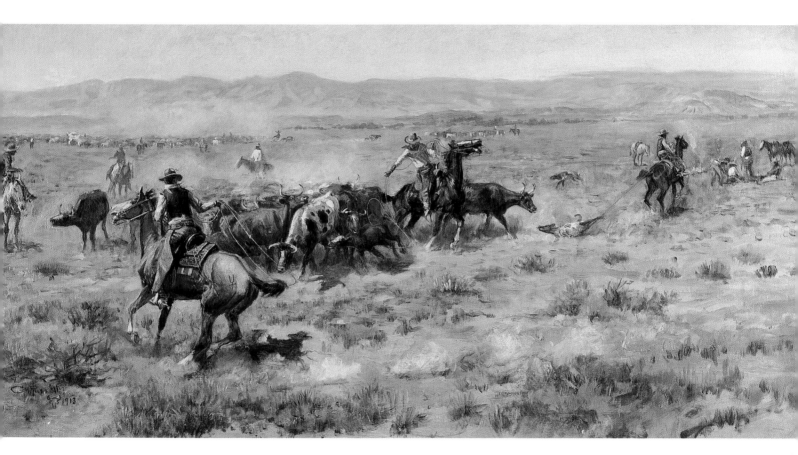

1881, but just for a visit, the first of several he was to make over the next few years. Not surprisingly he felt "cooped up" in the city and was soon back in Montana.

Oddly enough, it was this trip that presented Russell with the opportunity to do something he had longed to do: work as a cowhand. On his way back to Hoover's cabin he ran into a cow outfit on its way to pick up a thousand head of steer. They needed a horse wrangler. Charlie took the job. Though the position didn't last long (he soon returned to Jake's), it gave Charlie a taste of the buckeroo's life. He liked it.

And he must have been good because within months he had a job as night wrangler for the major local cattle syndicate, the Judith Pool. The night wrangler watches over the cow outfit's horses while they graze through the dark hours. It is a lonely but important job, and one that allowed the artist to continue to sketch during the day. Russell surely enjoyed the work because he con-

tinued in that capacity with various outfits for the next twelve years.

First Cowboy Compositions

Throughout this period, Russell followed the cycle that was the cowboy's life: spring round up, summer drives, fall round up, and the winter off, usually holed up on a ranch or in a rented room in Helena, Montana, or some other town. The slow periods allowed more time for his art, and by 1885 he was beginning to work in oils. The first of these to attract public attention, *Cowboy Camp During the Roundup*, was completed in 1887 on a commission from James R. Shelton, owner of a Utica, Montana, saloon.

The crude composition and awkward figures foretell little of the artist Russell was to become, but his work was well received by an audience who could recognize every cowhand among the dozen or so populating the foreground of the canvas.

Waiting for a Chinook (The Last of Five Thousand)

CHARLES M. RUSSELL

1886, watercolor on paper. Montana Historical Society, Helena, Montana. This tiny (3 x 4 in. [7.6 x 10.1 cm]) sketch, depicting the tragic consequences of the hard winter of 1886, brought Russell his first regional recognition.

However, it was a tiny watercolor sketch of a starving cow that first secured national recognition for Russell. The winter of 1886–87 was a bitter one, and the artist, living on an isolated ranch, watched thousands of cattle die of starvation, unable to reach the grass through 2 feet (.6 meters) of snow. His host, owner of the OH Ranch, found it necessary to write to a business associate advising him that the herds were nearly wiped out. Russell took a piece of paper, sketched a cow, and handed it to him. The rancher, Jesse Phelps, took one look and said, "Hell, he don't need a letter this will be enough."

The sketch, variously titled *Waiting for a Chinook* ("chinook" is the warm wind that would melt the snow) or *The Last of Five Thousand*, spoke to a Western audience. It was reproduced in prints and on postcards and adopted as a campaign illustration by the National Association for the Prevention of Cruelty to Animals. In addition it helped, at least indirectly, convince cattlemen that herds could not be left on the high plains without some provision to feed them during extreme weather conditions.

Russell realized little financially from the work, and it would be some years yet before he could earn a living as an artist. In fact, there is little evidence that at this point in his life he even considered the possibility of his art as a major source of income. In the meantime, he herded horses and cows and lived the life he had dreamed of as a boy. He rode the line, chased strays, and sat around the campfire talking and sketching. Between jobs or during the off-season he headed for town to drink and carouse with his partners. He was a drinker, something he never hid, but he also knew when to quit; and his good nature and sense of humor enabled him to avoid the shooting scrapes that carried off so many cowhands.

The year 1888 marked another important point in Russell's life. He had always been drawn to Native Americans and sympathetic to their plight, but so far he had had only sporadic contact with them. In '88, just after spring round up, Charlie and two friends struck out for Canada. The friends drifted off, but Russell settled down for a year with the Blood Indians, living with them in their village and learning their language.

During these months he not only studied the details of Native American dress, customs, and lifestyle that would enable him to accurately portray them in his later work, but he also became a

strong advocate of Indians in their struggle to survive white domination. His opinion of the relative merits of the two groups was clear:

> I've known some bad Injuns . . . but for every bad one I can match 'im with ten worse white men. Man for man, an Injun's as good as a white man any day. No Injun ever done me dirt. Many a one's done me favors. When he's a good friend, he's the best friend in the world.

Charlie established friendships among the Bloods, his closest with their chief, called Sleeping Thunder. Nor was this his last such relationship. A lifelong friend of his was Young Boy, a Cree who was among the first to offer condolences to the artist's widow after his death.

The Wounded Buffalo

CHARLES M. RUSSELL

1909, oil on canvas. Sid Richardson

Collection of Western Art, Fort Worth, Texas.

Few animals on this continent were more dangerous than a wounded bull bison—as this brave is discovering.

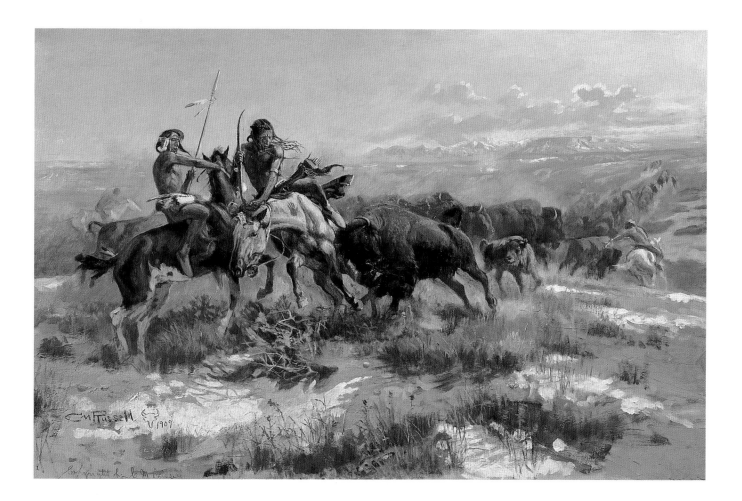

The Closing of the Frontier

Charlie was soon back wrangling in Montana, but times were changing. By 1890 the land was being cut up for farms with barbwire fences shutting out the once free, roaming cattle. In the bitter conflict between the farmers (called "nesters" by cowpokes) and the ranchers, Russell played a vociferous part. He loathed farmers for what they did to the open range:

> The farmer plowed up the grass. He drove the cattle away . . . Where we used to have grass, weeds grow now. Since the coyote got thinned out, there's lots of gophers. He killed the prairie chicken and sage hen, makin' it good for grasshoppers. He plants corn and gets tumbleweeds. Damn him! It serves 'im right.

Pushed out by civilization, the cow outfits moved north into Canada. Charlie worked intermittently on the plains above the Missouri River during the period between 1889 and 1892, but more and more of his time was devoted to his art. He was even beginning to get paid for it.

These early sales were of the most random sort, a herding scene in watercolors sold for $10 to buy grub or traded to cover a bar tab. A big commission would be a back-bar painting for a saloon owner at $75. Russell once even painted a grazing scene on the vault door of a local bank!

His reputation was also beginning to reach beyond the Western cow towns. In 1891 *Nature's Realm*, a natural history magazine published in New York, declared him to be "[o]ne of the best animal painters in the world." It was at this time also that the artist met Albert Trigg, a man who would become a lifelong friend and who was the first to successfully market Charlie's work.

As his sales increased and the cattle range shrank, Kid Russell, as he became known to his saddle pals, saw that his future lay in art rather than night wrangling. He rode out for the last time in the summer of '92, and that winter he settled in to paint full time. For the next couple of years, though, he barely got by, often trading paintings for food and lodging.

Nancy Russell

Everything changed in 1895, for Charlie now met Nancy Cooper, a young woman from Kentucky. She was only seventeen while he was thirty-one but they formed an immediate bond, and were married within the year. Nancy was an orphan with

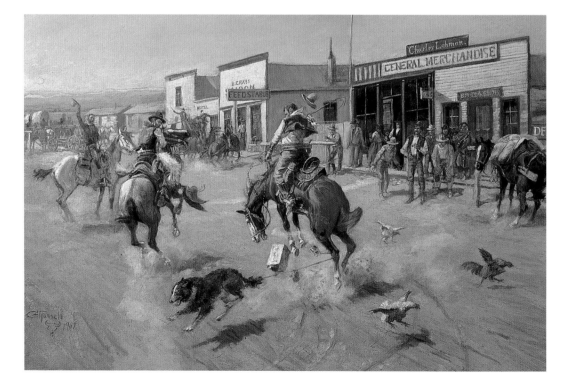

**Utica
(A Quiet Day
in Utica)**

CHARLES M. RUSSELL

1907, oil on canvas.

Sid Richardson

Collection of Western

Art, Fort Worth, Texas.

Utica, a tiny Montana
settlement well
known to the artist,
no doubt had many
such "quiet days"
when cowboys fresh
from the plains rode
in to have some fun.

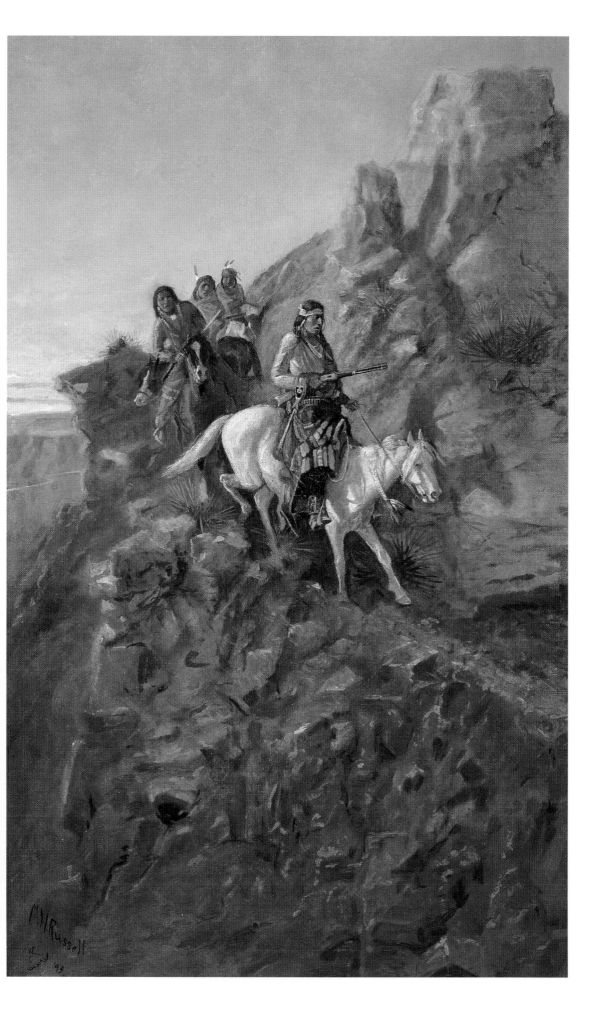

**There May be
Danger Ahead**

CHARLES M. RUSSELL

1893, oil on canvas.

Sid Richardson

Collection of Western

Art, Fort Worth, Texas.

A suggestion of un-
seen danger in the
riders' tense forms
and strained looks
draws the viewer
into the unfolding
high peaks drama.

little formal education, but she was bright and had a head for business. She immediately took Charlie in hand.

Recognizing that his drinking companions would never be art consumers and that time spent in saloons could be better spent in the studio, Nancy established a rigid work schedule for her husband and set about selling his art work. She talked to agents, studied the intricacies of copyright law, and upped the prices. Paintings that had sold previously for $25 now brought $75; then $500; and, soon enough, when the first one sold for $1,500 the astonished Russell declared to a friend, "My wife's just turned road agent! I saw 'er hold up a man this afternoon."

Nancy Russell also encouraged a move from the tiny town of Cascade to Great Falls, Montana, where, with the financial assistance of Charlie's father, they were able to build a house and the artist's first real studio. Constructed in 1903, this was a spacious log house with a great stone fireplace. It was decorated with bear rugs and the many Native American and cowboy artifacts Charlie had acquired in his Western adventuring.

In the same year, encouraged by Will Crawford and John Marchand—New York–based illustrators of Western subjects—and financed by the senior Russell, Charlie and Nancy went East. Their trip to New York was yet another milestone in the artist's career. He sold his first bronze sculpture and Nancy made important contacts with eastern publishers.

This was the first of his almost annual visits to New York. Charlie liked getting together with his artist friends and seeing to the casting of his bronzes, but he never got used to the city which he referred to as "the big camp." The contrast with Frederic Remington is interesting. While Russell traveled from his home in Montana to New York to "do business," Remington, situated in the East, traveled west to gain inspiration. They knew many of the same people, but their paths never crossed; in part, perhaps, because by the time Charlie had established himself as a western illustrator, Remington had largely withdrawn from that field in favor of "fine art."

Popular Success

After the first New York visit Russell's career accelerated. In 1905 he contracted to do a series of calendar illustrations at $500 each, the first of many such arrangements. The following year *Outing Magazine* commissioned the artist to do a series of illustrations on Mexican life. This led to the Russell's first foreign travel. Russell admired the country and spoke highly of the vaquero, the Mexican counterpart to the American cowboy.

Money was coming in steadily now. Charlie went into a brief ranching partnership (1906–11) with an old friend; and, in the early years of the new century he built a summer cabin, Bull's Head Lodge, on Lake McDonald in the Rocky Mountains. Thereafter, he and his wife spent most summers there and, later, their winters in southern California, where shortly before Charlie's death they began to build "Trail's End," a magnificent adobe-style home.

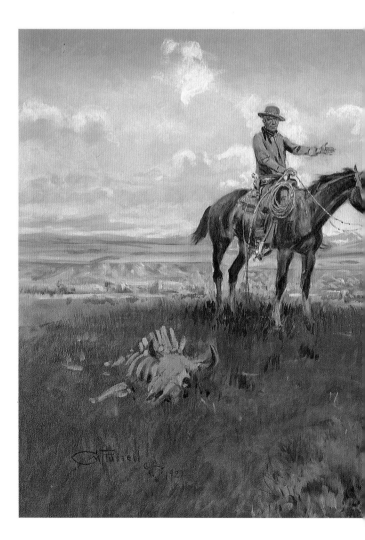

Russell's early success had been in illustration, and he was proud of this, declaring, "I am an illustrator. There are a lot better ones but some worse. Any man that can make a living doing what he likes is lucky, and I'm that." However, he still sought recognition as a painter, and this came in 1911 when New York's Folsom Galleries displayed twenty-five of his oils in a well received show entitled "The West That Has Passed." Other exhibitions across the country followed, as well as a major London show in 1914. By 1915 Russell was widely recognized as the most important living American illustrator of the West.

Russell was also an extremely popular man. He had befriended actor and humorist Will Rogers on the first New York trip, was acquainted with many artists like Charles Schreyvogel (whom Remington despised), L. M. Glackens, and Albert Levering, and, once the Russells began to spend their winters in California, frequently met those of the Hollywood crowd, numbering such stars as Tom Mix, Harold Lloyd, William S. Hart, and Douglas Fairbanks among his friends and customers.

The artist's career and marriage continued to flourish into the 1920s. Unfortunately, his health did not. He lost all his teeth, developed rheumatism, and was operated on for a recurrent goiter. Following this procedure Russell's health declined rapidly. In 1926 both he and Nancy had been told privately that he had but a few months to live. Each shielded the other from the knowledge. On October 24, 1926, his heart gave out. True to his wishes he was borne to the grave in a horse-drawn hearse rather than the modern motorized variety. Even in death Charlie Russell cheated the combustion engine.

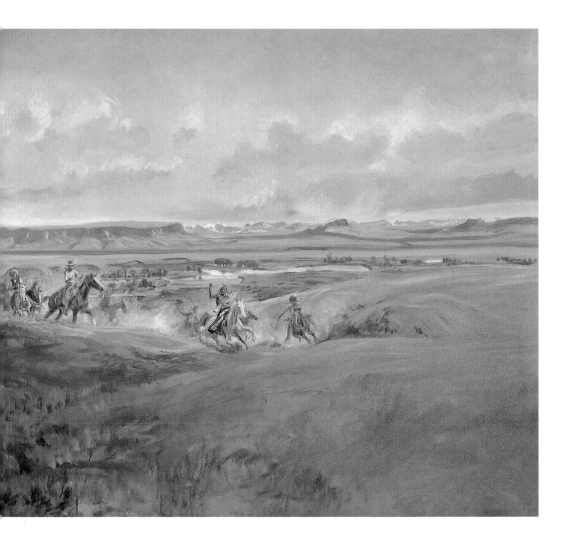

C. M. Russell and His Friends

CHARLES M. RUSSELL

n.d., lithograph on paper.

Montana Historical

Society, Helena, Montana.

This print of a scene of a gathering of the artist's old western cronies reflects the popularity Russell had obtained by the early 1900s.

FOLLOWING PAGE:

The Ambush

CHARLES M. RUSSELL

n.d., oil on canvas.

Montana Historical

Society, Helena, Montana.

One of the perils faced by western prospectors and hunters was ambush by Indian tribes who resented their trespass on traditional hunting grounds.

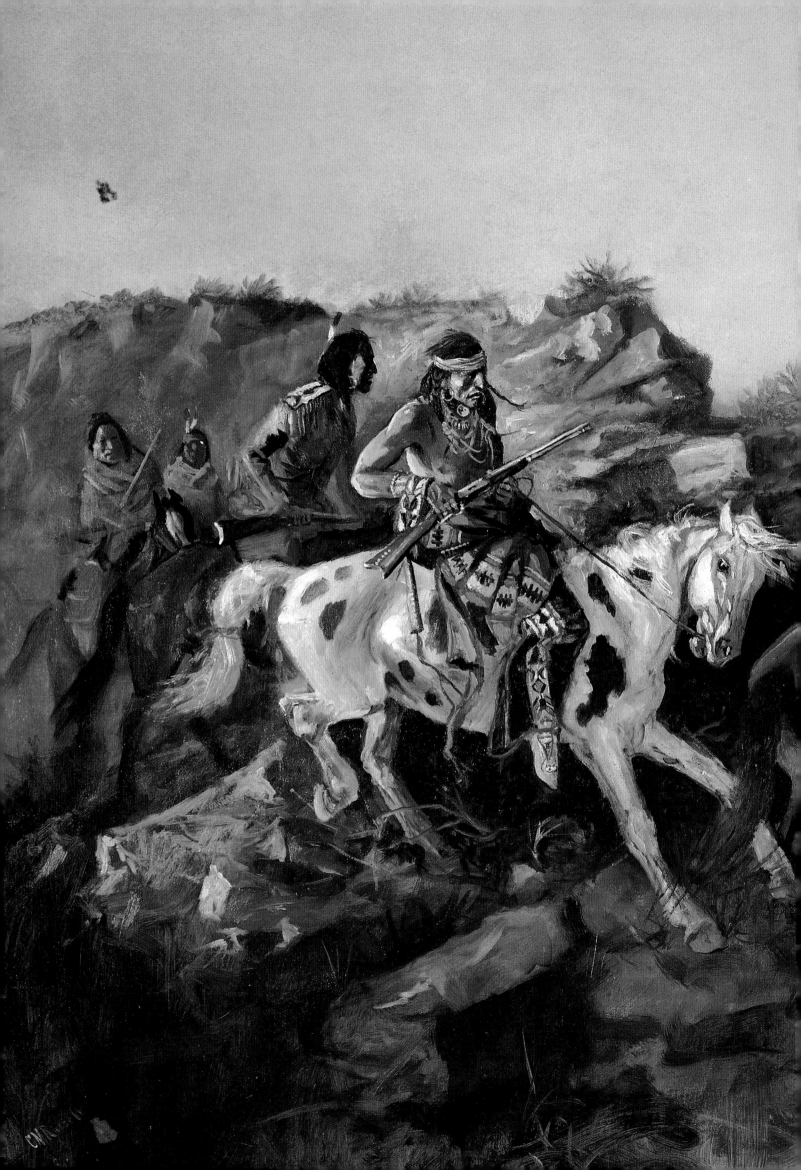

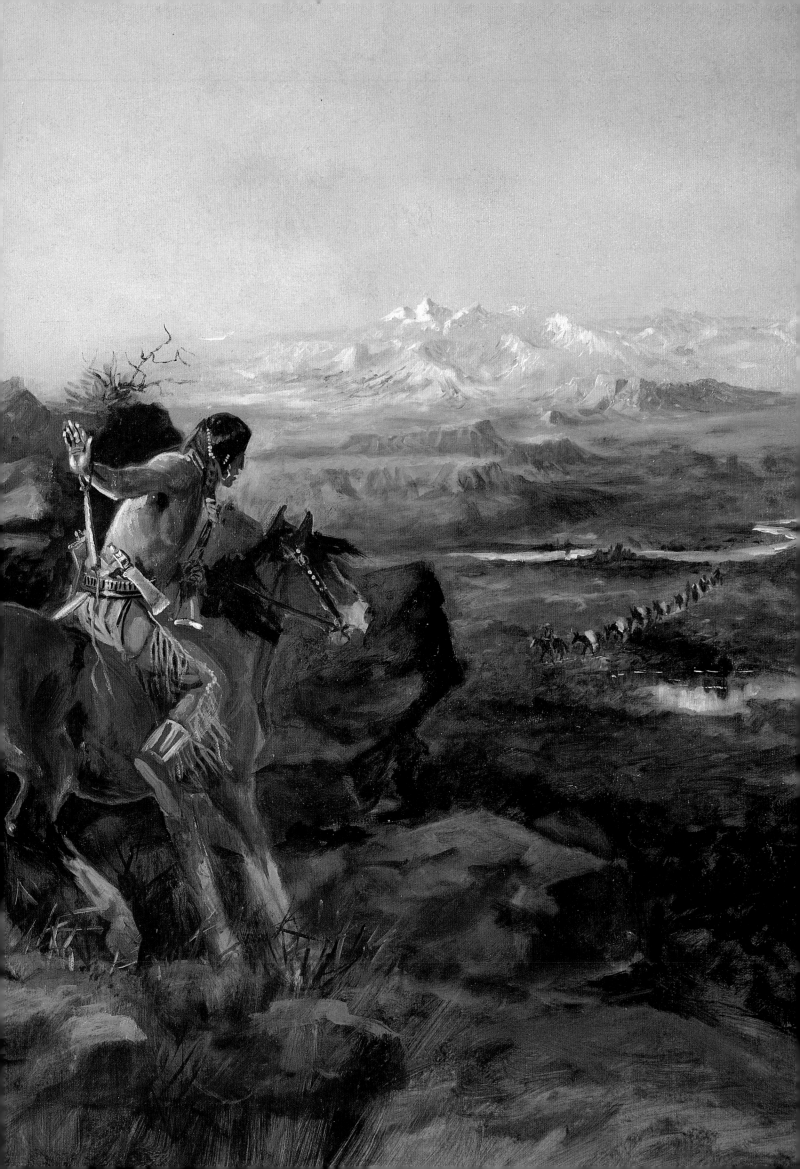

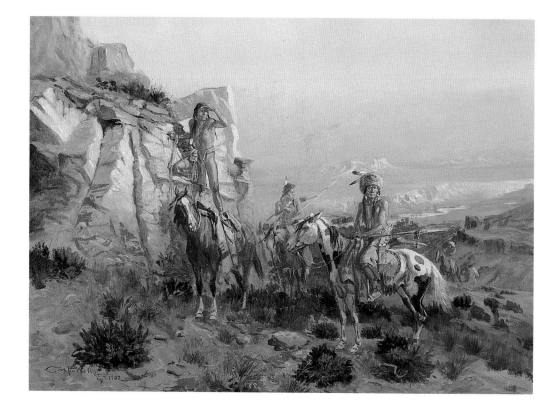

Trouble Hunters

CHARLES M. RUSSELL

1902, oil on canvas. Sid Richardson Collection
of Western Art, Fort Worth, Texas.

Russell appreciated the Native American's
way of life but he knew that it had a violent
side as well, which he captures in this rendi-
tion of a war party out for horses and scalps.

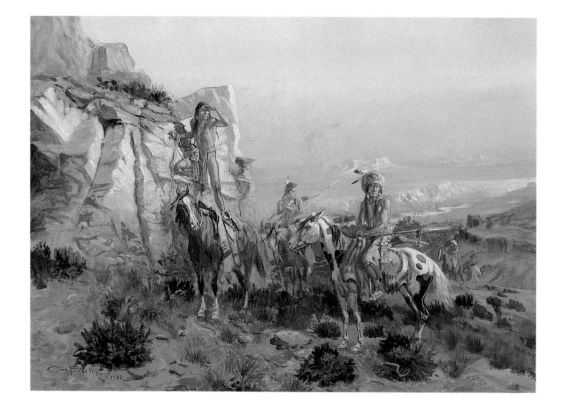

Trouble Hunters

CHARLES M. RUSSELL

1902, oil on canvas. Sid Richardson Collection
of Western Art, Fort Worth, Texas.

Russell appreciated the Native American's
way of life but he knew that it had a violent
side as well, which he captures in this rendi-
tion of a war party out for horses and scalps.

The Tenderfoot

CHARLES M. RUSSELL

1900, oil on canvas. Sid Richardson Collection
of Western Art, Fort Worth, Texas.

This humorous depiction of a not-so-funny situation
reflects the hostility often shown by cowpokes toward
new arrivals in the West, particularly those whose
dress or speech differed so markedly from their own.

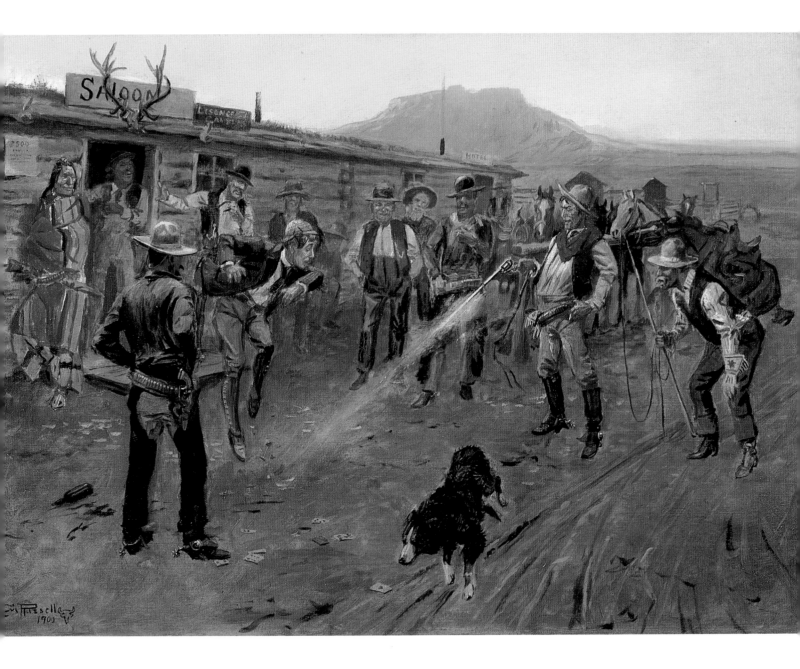

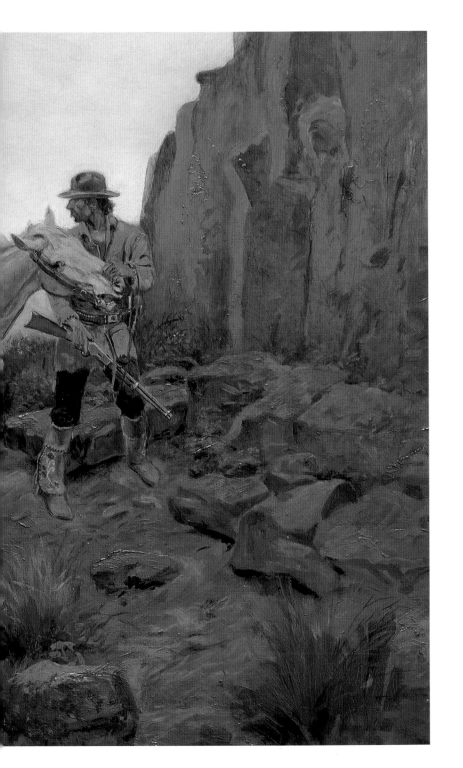

When Shadows Hint Death

CHARLES M. RUSSELL

1915, oil on canvas. Duquesne Club, Pittsburgh, Pennsylvania. In one of Russell's most dramatic compositions, the white men attempt to stifle their horses' whinnies while an Indian war party, suggested only by shadows on the canyon rim, passes on the bluff above them.

First Wagon Tracks

CHARLES M. RUSSELL

1908, watercolor. Sid Richardson Collection of
Western Art, Fort Worth, Texas.

The squatting Indian, with his hand over
his mouth in a gesture of amazement, reflects
the general consternation of his fellows at
this strange addition to the desert landscape.

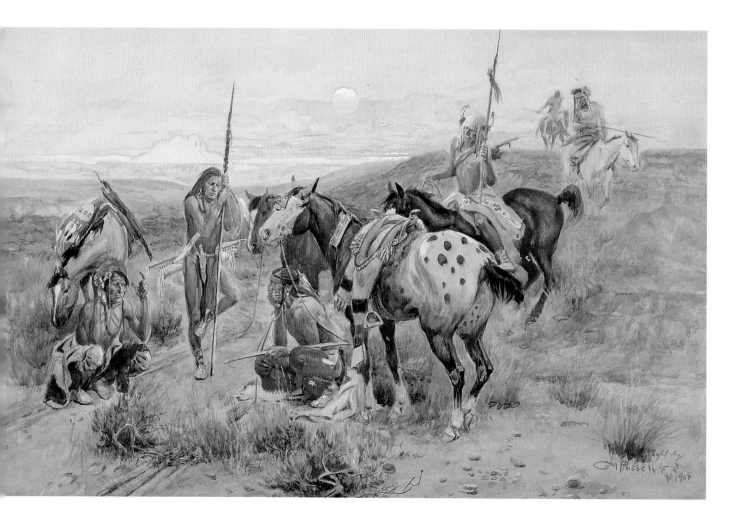

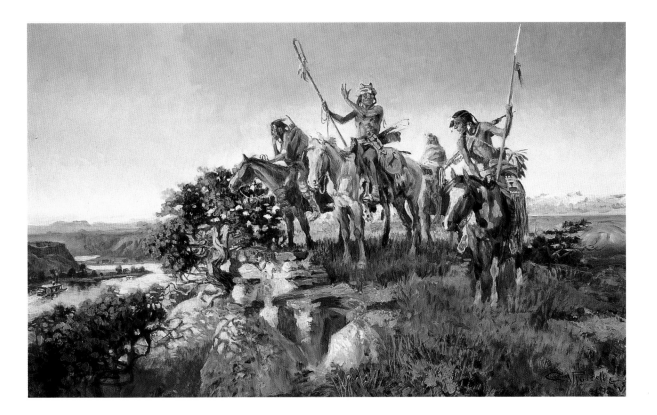

The Fireboat

CHARLES M. RUSSELL

1918, oil on canvas. C. M. Russell Museum,

Great Falls, Montana.

When the first steamboats appeared on the
Missouri River in the 1830s they were a source
of consternation for Native Americans, who
at first took them to be fire-breathing monsters!

Deer In Winter

CHARLES M. RUSSELL

n.d., oil on canvas.
Buffalo Bill Historical
Center, Cody, Wyoming.
During his years of
association with the
hunter Jake Hoover,
Russell had ample time
to observe the lives
of deer in their natural
habitat. Here, he ren-
ders the animals with a
sensitive and knowing eye.

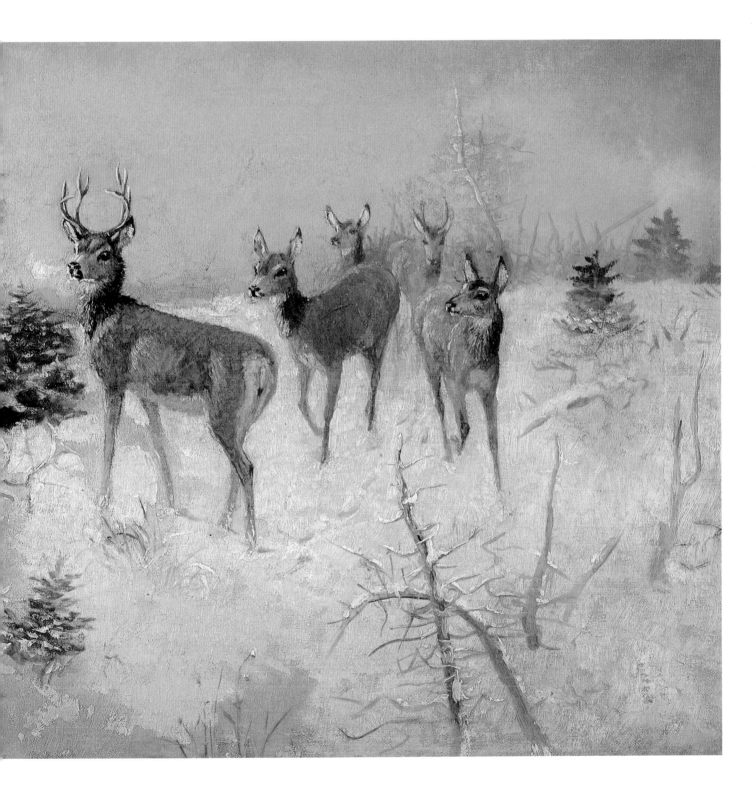

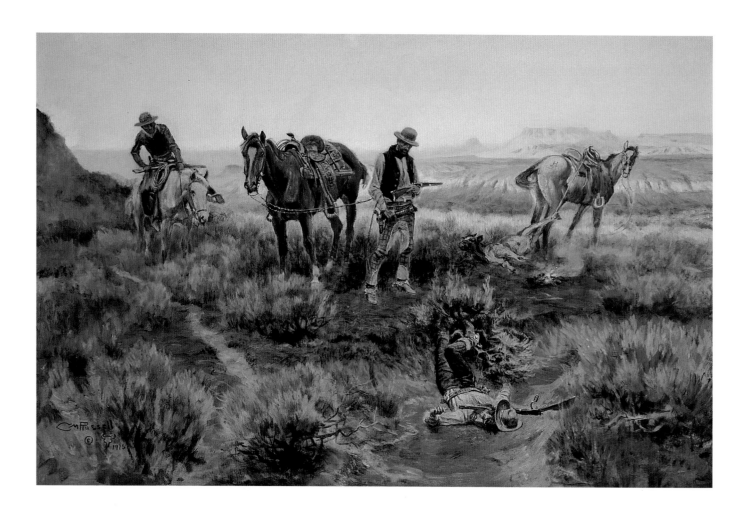

Paying the Fiddler

CHARLES M. RUSSELL

1919, oil on canvas. C. M. Russell Museum, Great Falls, Montana.

Though it is doubtful that he witnessed any such event, Russell knew that stealing
and branding another's cattle was an offense punishable by death on the western range.

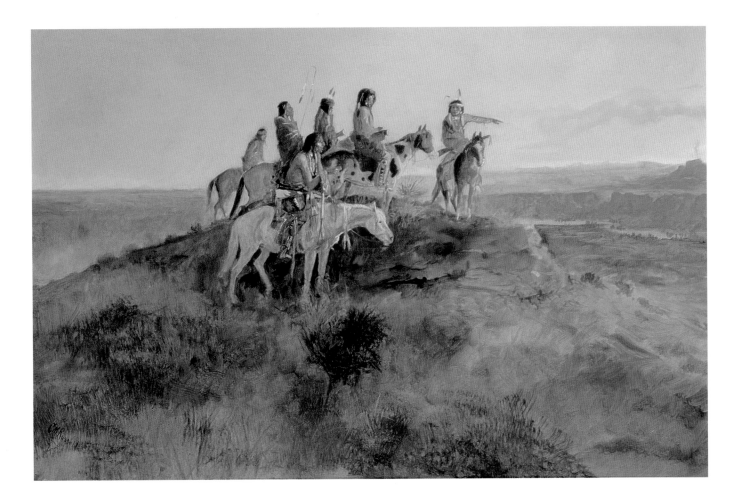

Signal Smoke

CHARLES M. RUSSELL

1914, oil on canvas. C. M. Russell Museum, Great Falls, Montana.

Smoke signals, which could be seen over great distances on the open

prairies, were a common method of communication among Native Americans.

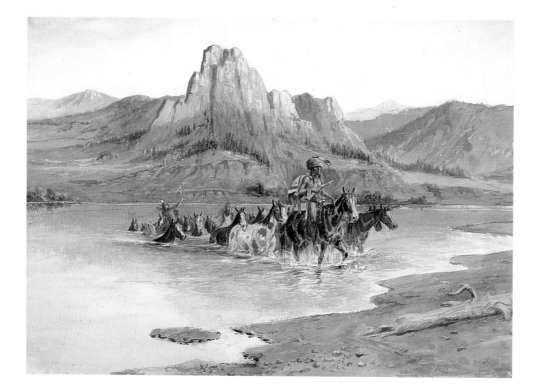

Return of the Horse Thieves

CHARLES M. RUSSELL

1900, watercolor. C. M. Russell Museum,

Great Falls, Montana.

Among Native Americans horses were
considered wealth, and the skilled horse
thief held an honored position in his tribe.

The Bucker

CHARLES M. RUSSELL

1904, watercolor. Sid Richardson Collection

of Western Art, Fort Worth, Texas.

Both Russell and Remington would at times
produce a painting after completing a sculpture.
This exercise in dynamic verticality may be
compared to Russell's bronze, *A Bronc Twister.*

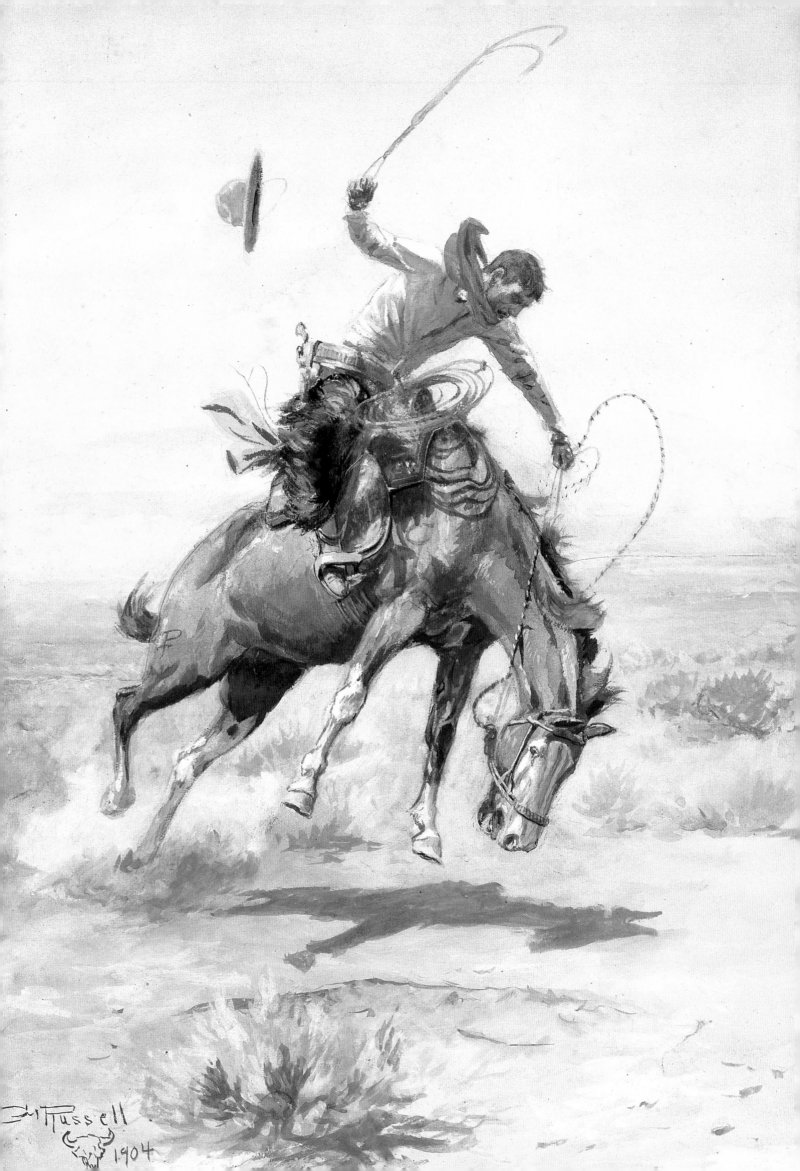

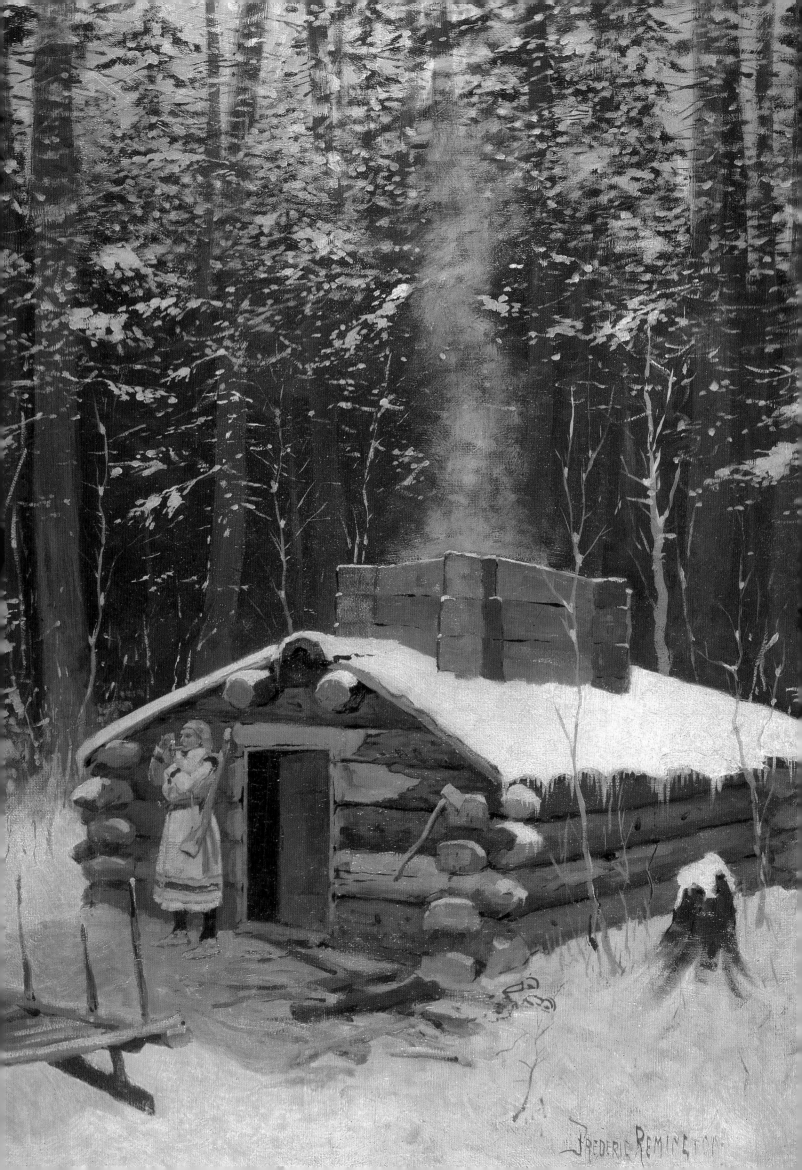

Frederic Remington: In His Father's Name

Though he pursued a variety of subjects, painter and sculptor Frederic Remington returned again and again to a favorite topic, the United States Army, and, in particular, the cavalry. This fascination, indeed an obsession, is readily traced to the artist's father, a legendary Civil War cavalry officer.

Early Experiences

Frederic was born on October 4, 1861, in Canton, New York, and only eight weeks later his father, owner and publisher of several north country newspapers, volunteered for Scott's 900, the first cavalry regiment enrolled for the Union cause. Pierre Remington's career was the stuff of legends, extending throughout the war and encompassing some seven major engagements, including one at Centerville, Virginia, where he led eighty-five men in a wild rush against eighteen hundred Confederate troops, an action described by a Southern publication as "the most gallant charge and the most desperate resistance we ever met from Federal cavalry."

Mustered out as a brevet Colonel on March 11, 1865, Seth Pierpont Remington (called Pierre) returned to Canton a conquering hero, admired by all and worshiped by his young son, who grew up hearing of his exploits. Indeed, so strong was the son's identification with his father that a cousin remarked in later years that she "never saw a picture made by Fred in which there were several faces, but that one was a picture of his father."

Though ferocious in war, Colonel Remington was a mild and gentle parent. His wife, Clara Sackrider Remington, was a retiring, family-oriented mother who had few interests outside the home. Both parents doted on their children.

Frederic, however, proved early on that he would be a problem. Strong and active, he loved outdoor sports and hated school. His father had

FOLLOWING PAGE:

Cabin in the Woods

FREDERIC REMINGTON

c. 1890, oil on canvas. Remington Art Museum, Ogdensburg, New York.

One of the artist's rare winter scenes, here the size of the trees and the hunter's clothing imply a Western rather than an Eastern woodland locale.

Aiding a Comrade

FREDERIC REMINGTON

c. 1890, oil on canvas. The Hogg Brothers Collection, Museum of Fine Arts, Houston, Texas.

This work is one of several renditions by the artist of a popular theme—troopers or cowboys pursued by Indians, here pausing to rescue a wounded companion. Combining courage and compassion, such illustrations had strong public appeal.

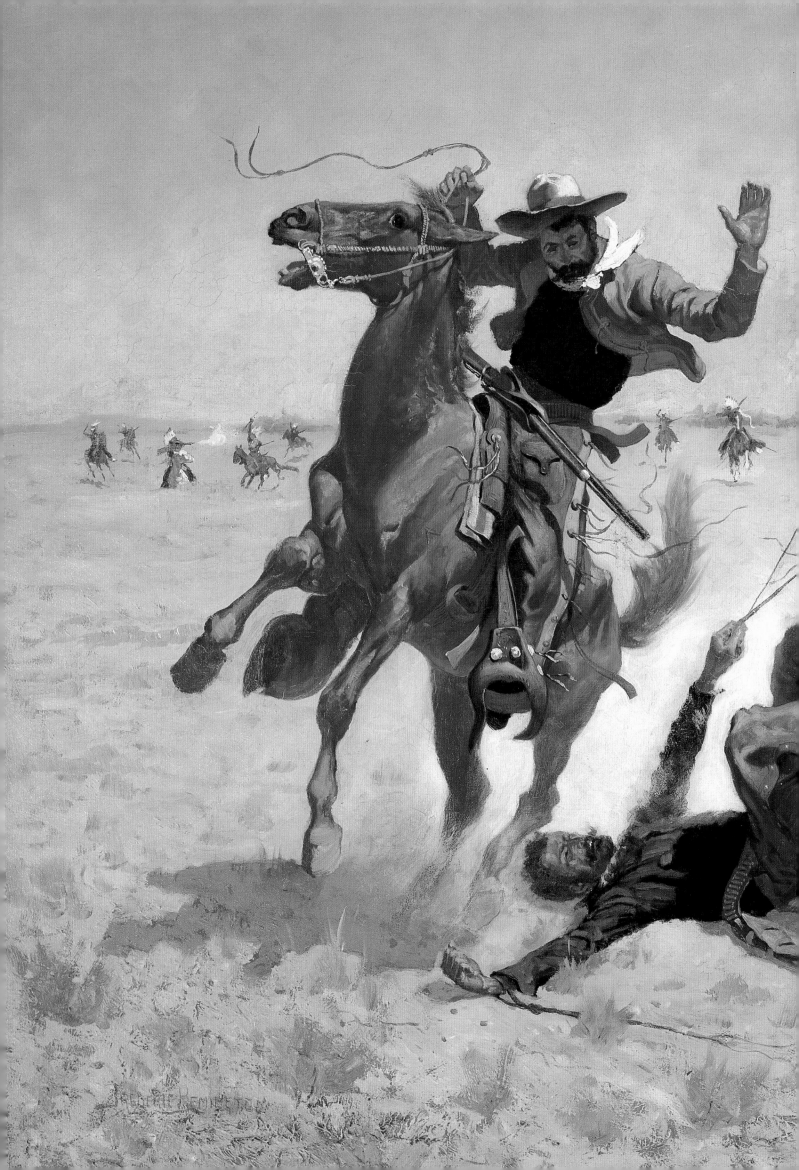

Frederic Remington: In His Father's Name

Though he pursued a variety of subjects, painter and sculptor Frederic Remington returned again and again to a favorite topic, the United States Army, and, in particular, the cavalry. This fascination, indeed an obsession, is readily traced to the artist's father, a legendary Civil War cavalry officer.

Early Experiences

Frederic was born on October 4, 1861, in Canton, New York, and only eight weeks later his father, owner and publisher of several north country newspapers, volunteered for Scott's 900, the first cavalry regiment enrolled for the Union cause. Pierre Remington's career was the stuff of legends, extending throughout the war and encompassing some seven major engagements, including one at Centerville, Virginia, where he led eighty-five men in a wild rush against eighteen hundred Confederate troops, an action described by a Southern publication as "the most gallant charge and the most desperate resistance we ever met from Federal cavalry."

Mustered out as a brevet Colonel on March 11, 1865, Seth Pierpont Remington (called Pierre) returned to Canton a conquering hero, admired by all and worshiped by his young son, who grew up hearing of his exploits. Indeed, so strong was the son's identification with his father that a cousin remarked in later years that she "never saw a picture made by Fred in which there were several faces, but that one was a picture of his father."

Though ferocious in war, Colonel Remington was a mild and gentle parent. His wife, Clara Sackrider Remington, was a retiring, family-oriented mother who had few interests outside the home. Both parents doted on their children.

Frederic, however, proved early on that he would be a problem. Strong and active, he loved outdoor sports and hated school. His father had

Cabin in the Woods

FREDERIC REMINGTON

c. 1890, oil on canvas. Remington Art Museum, Ogdensburg, New York.

One of the artist's rare winter scenes, here the size of the trees and the hunter's clothing imply a Western rather than an Eastern woodland locale.

FOLLOWING PAGE:

Aiding a Comrade

FREDERIC REMINGTON

c. 1890, oil on canvas. The Hogg Brothers Collection, Museum of Fine Arts, Houston, Texas.

This work is one of several renditions by the artist of a popular theme—troopers or cowboys pursued by Indians, here pausing to rescue a wounded companion. Combining courage and compassion, such illustrations had strong public appeal.

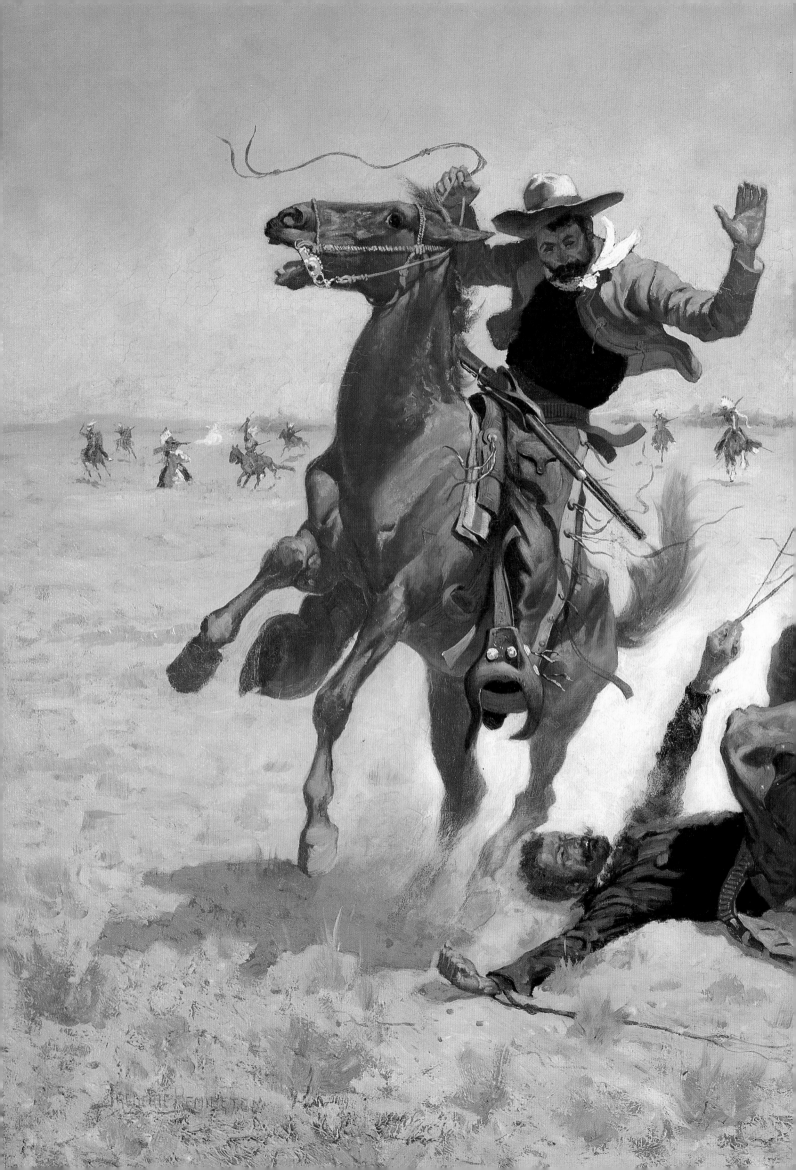

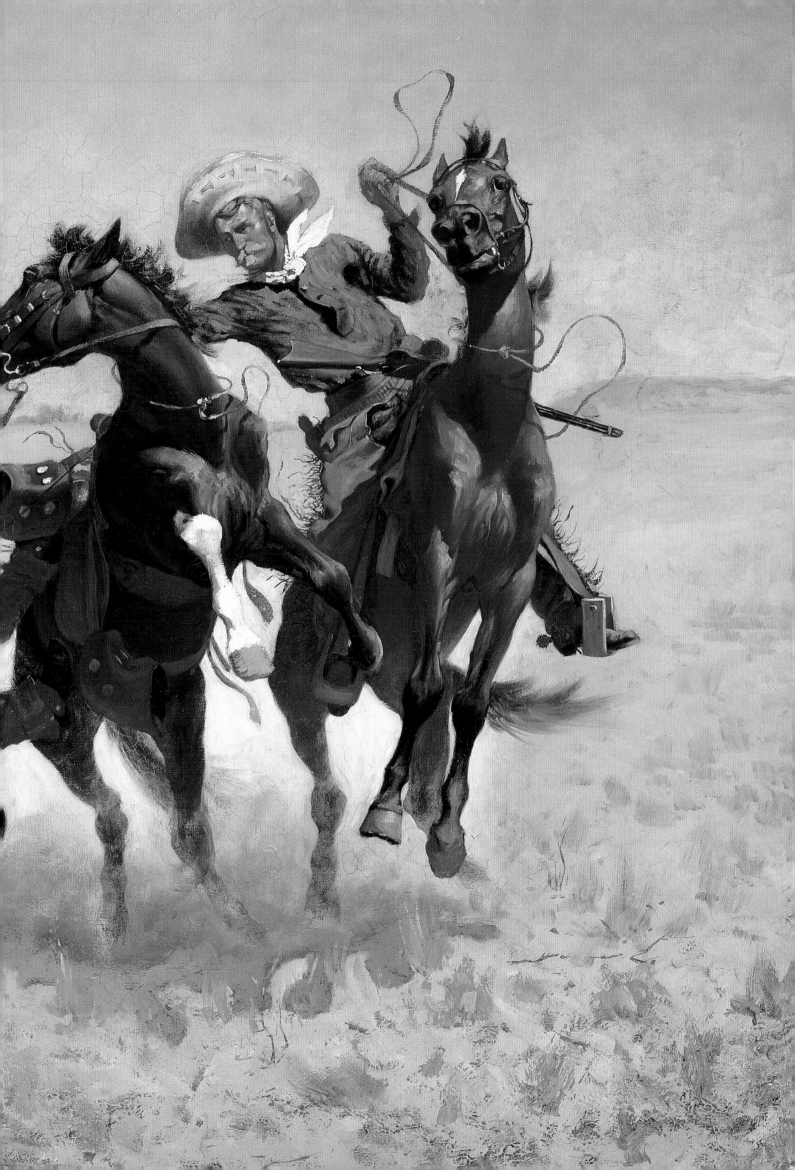

hoped for his son's eventual appointment to West Point which, given the Colonel's status, could probably have been readily arranged for even a mediocre student. But Fred was no student at all.

Still, he moved along until at the age of fourteen his parents sent him off to a well known military academy, the Vermont Episcopal Institute, near Burlington. He lasted a year, liking the military uniforms but hating the discipline, the academic courses, and what he felt was the paucity of nourishment. Already, Frederic was a big eater.

Like Charles Russell, Remington had shown early artistic talent. He was sketching by the age of three and, following some training at the Institute, he produced his first painting, *The Chained Gaul*, in the summer of 1876. It may have pleased the youth but not his grandmother, who is said to have remarked, "Fred, you will never amount to anything."

That fall Remington was sent to another preparatory school, the Highland Military Academy in Worcester, Massachusetts. He was reasonably happy here, remaining for two years, surviving not academically but through his cheerful personality and impressive physique. Weighing a healthy 180 pounds (81 kilograms), Frederic excelled in athletics. He also, however, continued to draw, and already his favorite subject was the army.

But there was a parallel talent. Remington had inherited his father's literary penchant; and his letters of the period, while sometimes full of unusual grammatical constructions, foreshadowed his future role as author and playwright.

In fact, he had hoped to enroll at Cornell to pursue a course in journalism. However, when he learned that Yale offered both a School of Fine Arts and an English major, Frederic chose to go there. Entering in 1878, he found himself the only student in the freshman class to opt for an art education.

He was not fond of his artistic training which consisted primarily of sketching in a dank basement filled with plaster casts of classical sculptures, but he liked the social life. And he found an outlet for his physicality, being selected early in his sophomore year as a member of the Yale football team captained by the legendary Walter Camp. Years later Remington was to claim, falsely, that he had, with Camp, invented the game!

Frederic did not return to Yale after the fall 1879 term. His father had tuberculosis and was dead by February of 1880. Pierre had been forty-six; his son was eighteen. It was a staggering blow to the boy.

A First Trip West

Frederic was at a loss. He had inherited a sizable sum, but he had no idea what to do with it or with himself. At the suggestion of an uncle he embarked on a short but unproductive career as a political appointee. Since the family was well connected in the ruling Republican party, the young man was assigned to a succession of patronage jobs in Albany, New York, the state capital.

While distasteful, these would, he hoped, offer the opportunity to marry his sweetheart, Eva Caten, the daughter of a Gloversville, New York, businessman, whom he had met the prior summer. He asked her father for her hand in the Victorian manner and was turned down: he was considered to be too young and of dubious prospects.

Stunned by a second loss within the year, Frederic wandered from job to job, political and journalistic—all provided by the powerful, close knit Remington family. He was not, at this point, focused on an artistic future. He was, however, interested in seeing the West; and in August of 1881 he took the train to the Dakota Territory, traveling from there on into Montana. It was a short trip (he was back home by mid-October), but it proved to be an enlightening one.

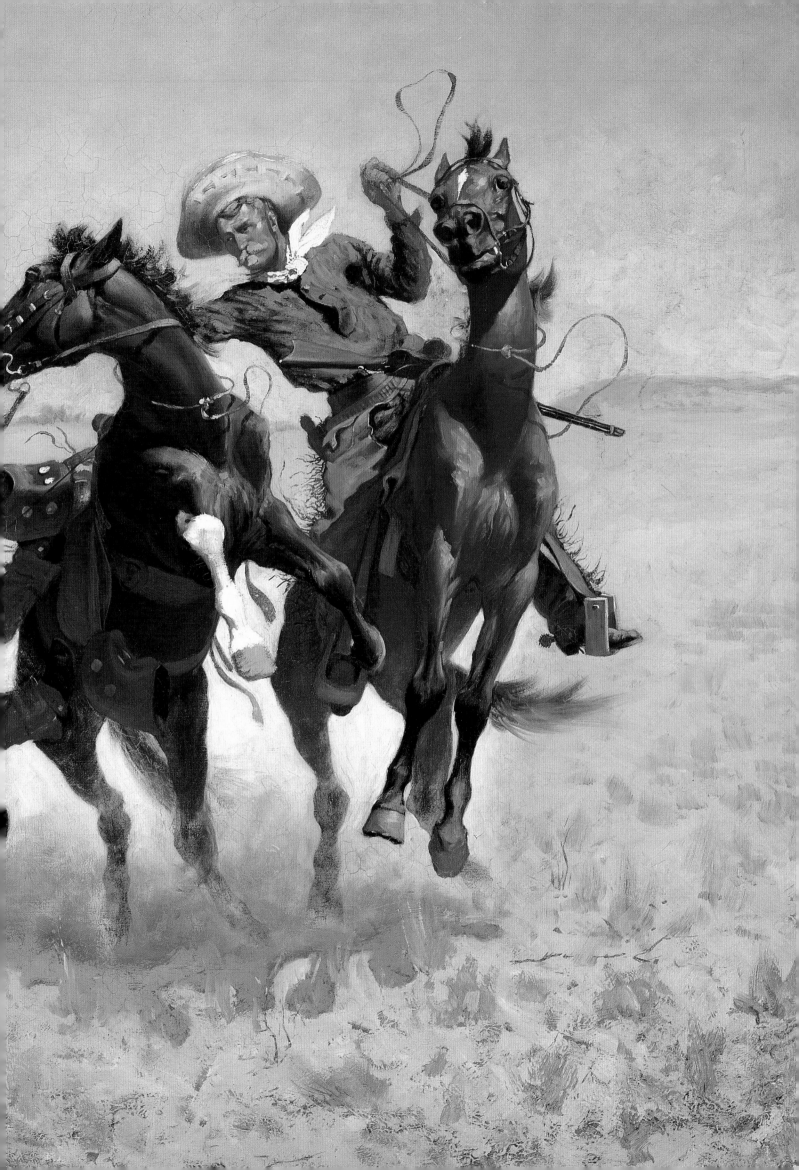

hoped for his son's eventual appointment to West Point which, given the Colonel's status, could probably have been readily arranged for even a mediocre student. But Fred was no student at all.

Still, he moved along until at the age of fourteen his parents sent him off to a well known military academy, the Vermont Episcopal Institute, near Burlington. He lasted a year, liking the military uniforms but hating the discipline, the academic courses, and what he felt was the paucity of nourishment. Already, Frederic was a big eater.

Like Charles Russell, Remington had shown early artistic talent. He was sketching by the age of three and, following some training at the Institute, he produced his first painting, *The Chained Gaul*, in the summer of 1876. It may have pleased the youth but not his grandmother, who is said to have remarked, "Fred, you will never amount to anything."

That fall Remington was sent to another preparatory school, the Highland Military Academy in Worcester, Massachusetts. He was reasonably happy here, remaining for two years, surviving not academically but through his cheerful personality and impressive physique. Weighing a healthy 180 pounds (81 kilograms), Frederic excelled in athletics. He also, however, continued to draw, and already his favorite subject was the army.

But there was a parallel talent. Remington had inherited his father's literary penchant; and his letters of the period, while sometimes full of unusual grammatical constructions, foreshadowed his future role as author and playwright.

In fact, he had hoped to enroll at Cornell to pursue a course in journalism. However, when he learned that Yale offered both a School of Fine Arts and an English major, Frederic chose to go there. Entering in 1878, he found himself the only student in the freshman class to opt for an art education.

He was not fond of his artistic training which consisted primarily of sketching in a dank basement filled with plaster casts of classical sculptures, but he liked the social life. And he found an outlet for his physicality, being selected early in his sophomore year as a member of the Yale football team captained by the legendary Walter Camp. Years later Remington was to claim, falsely, that he had, with Camp, invented the game!

Frederic did not return to Yale after the fall 1879 term. His father had tuberculosis and was dead by February of 1880. Pierre had been forty-six; his son was eighteen. It was a staggering blow to the boy.

A First Trip West

Frederic was at a loss. He had inherited a sizable sum, but he had no idea what to do with it or with himself. At the suggestion of an uncle he embarked on a short but unproductive career as a political appointee. Since the family was well connected in the ruling Republican party, the young man was assigned to a succession of patronage jobs in Albany, New York, the state capital.

While distasteful, these would, he hoped, offer the opportunity to marry his sweetheart, Eva Caten, the daughter of a Gloversville, New York, businessman, whom he had met the prior summer. He asked her father for her hand in the Victorian manner and was turned down: he was considered to be too young and of dubious prospects.

Stunned by a second loss within the year, Frederic wandered from job to job, political and journalistic—all provided by the powerful, close knit Remington family. He was not, at this point, focused on an artistic future. He was, however, interested in seeing the West; and in August of 1881 he took the train to the Dakota Territory, traveling from there on into Montana. It was a short trip (he was back home by mid-October), but it proved to be an enlightening one.

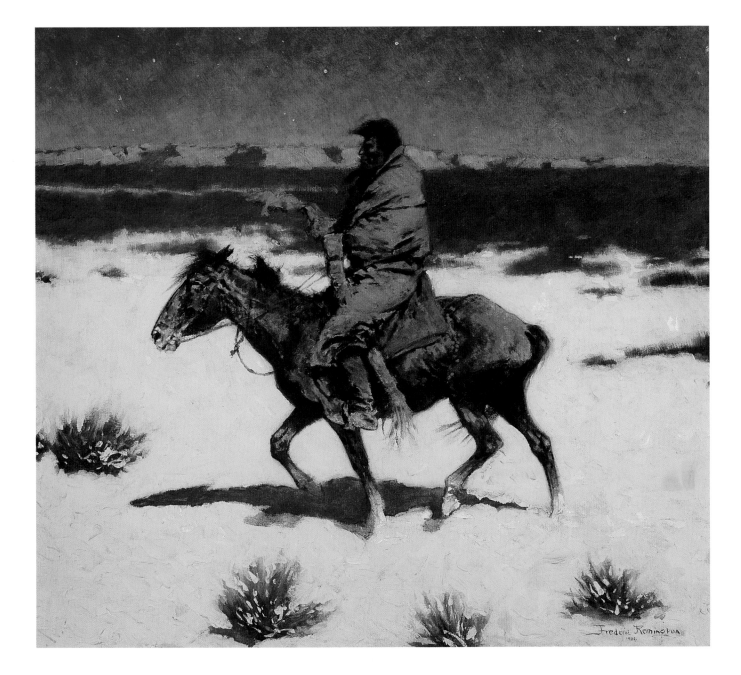

The Luckless Hunter

FREDERIC REMINGTON

1909, oil on canvas. Sid Richardson Collection
of Western Art, Fort Worth, Texas.

Winter on the plains could be a lean
time for Native Americans who were
able to store little food to tide them over.
Those who failed to find game were often
reduced to eating roots and dried berries.

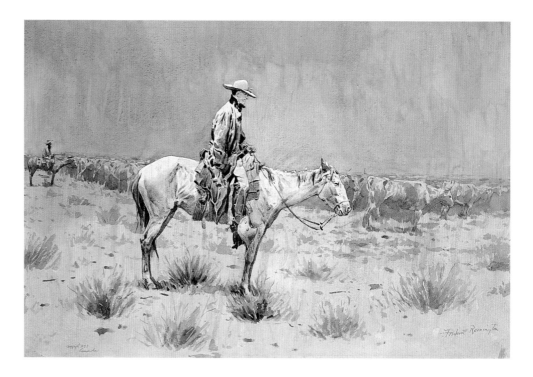

**Riding Herd
on the Range**

FREDERIC REMINGTON

c. 1897, wash drawing.

Buffalo Bill Historical

Center, Cody, Wyoming.

This typical herding

scene is done in a

black-and-white wash,

the medium that

Remington employed

for many of his

popular illustrations.

Remington witnessed the last great bison slaughter, the beginning of the brief Montana cattle boom ("Kid" Russell was there, too, at this time, somewhere in the Judith Basin), and discovered that while there was money in both ranching and mining (several Harvard and Yale graduates were already on the scene), it took more capital than he then had. In later years he would claim he'd seen that all this would soon pass away:

> I knew the railroad was coming. I saw men already swarming into the land. I knew the derby hat, the smoking chimneys, the cord-binder, and the thirty day note were upon us in a restless surge. I knew the wild riders and the vacant land were about to vanish forever . . . Without knowing exactly how to do it, I began to try to record some facts around me, and the more I looked the more panorama unfolded.

The thought of a new career was upon him. When he returned, his portfolio full of drawings, he met with the editor of the well-known *Harper's Weekly* in New York and one of the sketches was sold. His first arrow shot toward a career in art hit the mark. Reworked by a staff artist, it was published in late 1882.

Sheep Rancher and Businessman

Remington was now determined to go West again, not merely as an artist but as a rancher. In October of 1882 he came into his majority and his full inheritance, some $10,000. By March he was in Peabody, Kansas, where, under the guidance of another Yalie, Robert Camp, he purchased a small sheep ranch.

Frederic very soon learned to hate sheep, and within a year he had sold the ranch, taking a $2,000 loss on his total investment of $9,000. In later life he expunged all reference to this period from his biography, claiming instead (untruthfully) that he had been a cattle rancher and cowboy.

Remington's next western venture was a hardware store in Kansas City, Missouri. Some bad luck happened here. No one knows exactly what, but the artist claimed to have been "swindled," and he and his partner lost their investment. Undeterred, Remington became the silent partner in a saloon, another occupation that he saw fit to gloss over in later years.

Emboldened by this new venture he again asked Eva Caten for her hand. This time the family accepted and, in October of 1884, he brought his new

wife to Kansas City. It was nearly a disaster. Eva soon learned what her husband was really doing (not the brokerage but the booze business); she hated the raw new city and was terrified when she learned that even the saloon had failed. She fled back to Gloversville.

Now nearly penniless, Remington did not panic. In fact he seemed to revel in his freedom. He had been sketching throughout his western sojourn; now he turned to oils. Three paintings with western subjects that he consigned to a Kansas City art store sold instantly, followed by a larger work at the substantial sum of $250.

However, this new career did not prosper as he had hoped in Kansas City, and he missed his wife. Following three-way negotiations which included Frederic's Uncle Bill, the only member of the family who believed Frederic could succeed as an artist, the failed businessman returned East—to Brooklyn, New York. Remington never lived in the West again.

The Life of an Artist

Astonishingly, in less than a year Remington had established himself as an illustrator. In his characteristic fashion, he went right to the top—to Henry Harper, head of the city's premier publisher, Harper & Brothers. He appears to have stunned Harper with his larger-than-life personality, for the publisher later described Remington as "a young Hercules" possessing the "vigor and enthusiasm of a young artist."

Remington's arrival was timely. People were becoming fascinated with the West, and particularly with the futile pursuit by Federal troops of the legendary Apache leader Geronimo. Yet there was no artist in the East knowledgeable enough to picture Western locales, much less the Native Americans who lived there. Remington's work was still crude but it rang with authenticity. Harper bought the package.

Remington's third published illustration, *The Apache War: Indian Scouts on the Trail of Geronimo*, made the cover of the January 9, 1886, *Harper's Weekly*. In May Remington was on a westbound express for New Mexico assigned to provide *Harper's* with an update on Geronimo's whereabouts. Thus

began that period of his life when he was both artist and quasi–war correspondent, entering upon his close relationship with the U.S. Army.

His journal of this trip reflects his personality: flamboyant, always hungry, and frequently in need of a drink; quick to praise white frontiersmen on whose faces he saw "a very marked stamp of physical courage" and as quick to dislike Mexicans, at one time calling them "a villainous looking set . . . very degraded."

Remington quickly saw that tracking down Geronimo was going to take time and involve hard work as well as no little danger. So he rewrote his assignment. "Pursuit of Geronimo" became "Soldiering in the Southwest," and he settled down in Tucson, where he made the acquaintance of Lt. Powhatan H. Clarke, a dashing young officer with a reputation for bravery and recklessness. Their friendship, lasting over some years, was to prove beneficial to both. Clarke provided Remington with exciting copy, and the artist-correspondent made Clarke a legend in his own time. Remington also met General Nelson Miles, who was to become another longtime associate.

Remington began on this trip to employ a camera to capture scenes for later development into paintings and to gather Native American artifacts to be used as props to the same end. He was not the first of the artists of the West to do this, but he was one of the most thorough.

From Arizona Remington went on to Mexico to sketch the Yaqui Indians and Mexican army regulars. Neither the warm weather nor the inhabitants pleased him. He described Hermosillo as having a climate that "approximates hell very closely" and he hated the way the Mexicans treated animals, particularly horses. He lasted two days south of the border and was back in Brooklyn by the end of June, 1886.

Special Correspondent

Eva Remington, a product of the bourgeois mercantile class, had loathed the fact that her husband wanted to be an artist; indeed, her flight from Kansas City had been precipitated by the discovery that he was serious about his art. Now,

however, she reveled in his new status as "Special Correspondent" for *Harper's*.

His illustrated articles on the Southwest started running in *Harper's Weekly* in July, highlighted by a dramatic cover depicting Lt. Clarke rescuing a wounded black cavalryman under heavy Indian fire. This incident, which would have in the normal course of things resulted in some modest commendation for the officer, became a *cause célèbre* due to an unsigned letter to the press which urged that Clarke receive the Congressional Medal of Honor. The letter's author was, of course, Frederic Remington. Overnight the lieutenant became a national hero, and Frederic's illustration catapulted him to the top of his field.

There was not enough work at *Harper's* to satisfy Remington, and he looked for other outlets, quickly catching on with *St. Nicholas*, a children's magazine and, through his Yale connections, *Outing*, a publication on outdoor life. By the end of 1886 the artist had earned $1,200, far more than he could have in the clerkships his wife and family were always pushing him toward.

Early in 1887 the family moved to new and larger quarters in Brooklyn, and Remington began to enter watercolors in exhibitions, selling one such work which had been exhibited at the American Water Color Society. He was allowed to enter another (it did not sell) at the more prestigious National Academy of Design exhibition, where the painter went head to head with such luminaries as Winslow Homer and Eastman Johnson. Though he made no great point of it, Remington was already looking beyond magazine illustration.

In April of the same year he got a *Harper's* commission to sketch the life and tribes of the Canadian Northwest. A year later Russell would be in the same general area, and the contrast in the two artists' experience is striking. Charlie lived with a branch of the Blackfeet, learned their language, and freely sketched them. Remington, essentially an artistic tourist, was nearly tomahawked by an angry brave when he tried to take his picture and was shocked at their lack of appreciation. After all, the painter was, in his words, "endeavoring to immortalize" them!

Nevertheless, the trip was a success. Remington's illustrations ran weekly in *Harper's* for the

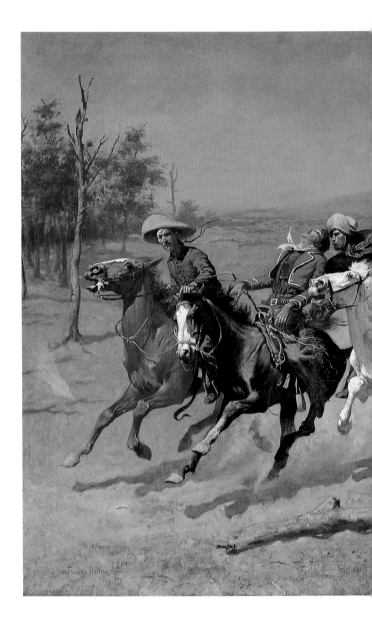

next year and a half, and the money rolled in. In the fall the Remingtons moved to Manhattan's elite Marlborough House, and the artist reached another plateau; he was commissioned to do the illustration for Theodore Roosevelt's book *Ranch Life and the Hunting Trail*. Thus began a long and mixed association with the future president.

His illustrated article, "Horses of the Plains," published by *Century* in January 1889, established him as a leading authority on the American bronco, and a watercolor, exhibited at the National Academy that year, quickly sold. Eva was delighted, writing to a relative that "Fred . . . has all he can do . . . and is told by artists that he is talked about more than any artist in this country & everyone looks upon him as the strongest man."

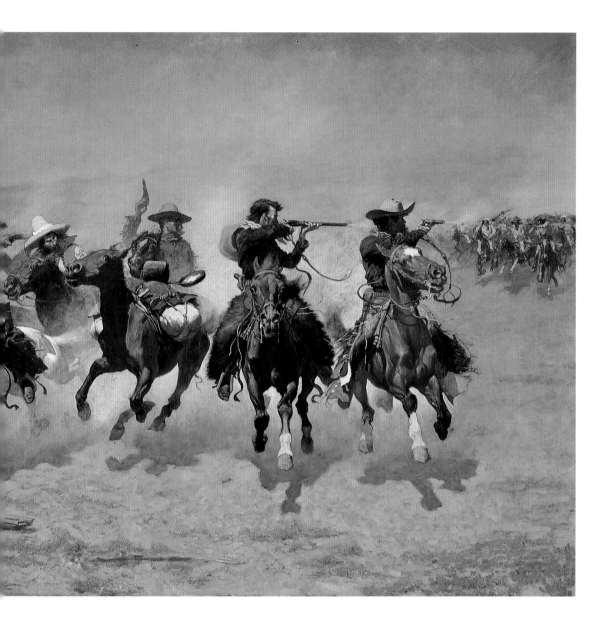

A Dash for the Timber

FREDERIC REMINGTON
1889, oil on canvas.
Amon Carter Museum,
Fort Worth, Texas.
This dynamic composition of cowboys pursued by Apache Indians has always been regarded as one of Remington's finest works. When displayed at the National Academy of Design in 1889 it was hailed by *The New York Herald* as ". . . an advance on the part of one of the strongest of our young artists."

Though already a stout 200 pounds (90 kilograms) and affecting both European dress and an English accent, Remington was still an athlete. Despite his recent lack of exercise he endured, along with Lt. Clarke and a half dozen of the black so-called Buffalo Soldiers, a grueling two-week scout on horseback through desert and mountain, much to the surprise of his companions.

In 1889 he spent another six weeks in Mexico on assignment for *Harper's*. He did not like it any better but did some fine illustrations to accompany an article which ran in the Harper firm's top publication, the glossy *Harper's Monthly*. Other triumphs followed. His *The Last Lull in the Fight* took a second-class medal at the Paris Exposition, and his first large (4 x 7 ft. [1.22 x 2.135 m]) oil *A Dash for the Timber* was shown

that year at the National Academy to great critical acclaim.

Meanwhile, Remington's relationship with the army deepened. In 1890 he toured California and parts of Canada at the invitation of his old friend General Miles, now Commander of the Pacific Division (packaging the trip with a commission from *Harper's*, of course), and later the same year was invited to Montana to observe the northern Cheyenne.

He also became involved in the current dispute over how to deal with the so-called Indian question. Remington favored the novel idea put forth by Miles and others of organizing the braves as an "irregular cavalry" under military control. The opposite position, that of control by civilian appointees, won out; to Remington's mind, though,

the presence of incompetent, often corrupt, Indian agents led directly to the Indian uprising of 1890.

Whatever the case, Remington in his role of special correspondent was on the scene—sort of. He made it to South Dakota in December, three days after Sitting Bull had been murdered at the Pine Ridge Reservation. Expecting that hostilities would soon break out, Frederic got a ride with a supply train heading to the reservation.

He never got there but he did get as close to Indian fighting as he probably ever wanted to be. The train was surrounded by a band of Sioux and, after a tense standoff, was able to withdraw to safety. His military companions thought the artist had had "a bad fright." He didn't disagree, and by the time he did get to Pine Ridge the Indian war was over.

However, there was still the matter of the massacre at Wounded Knee Creek. Remington wrote an article depicting the slaughter there of women, children, and old men as a "glorious encounter." Even Miles knew this wasn't true. In fact he court-martialed the senior officer in charge. But, in large part due to Remington's report, the man was exonerated. In all fairness, though, most white Americans at the time would have agreed with the artist.

Fine Art and Good Faith

Meanwhile, in December of 1889 the Remingtons had purchased a home in New Rochelle, New York, a booming community some 20 miles (32 kilometers) northeast of Manhattan. Called Endion (an Algonquin word for "the place where I live"), it consisted of a large brick home and a studio on three acres of land. Here they would stay for the next twenty years. Further, in April of 1890 his first one-man show had opened at New York's American Art Galleries.

The artist exhibited again in 1891 at the National Academy of Design and, in June, was elected an Associate of the Academy, a reflection of the fact that he was regarded by now as a fine artist and not just as an illustrator. In the long run, though, this proved a hollow honor; what Remington wanted most of all was election as a full member of the Academy, and thanks to his own aggressive personality and envy on the part of certain acade-

Indians Simulating Buffalo

Frederic Remington

1908, oil on canvas. Toledo Museum of Art, Toledo, Ohio. Covered with buffalo robes and crouched over horses which grazed closer and closer to the bison herds, Indian hunters could penetrate within striking distance of their prey.

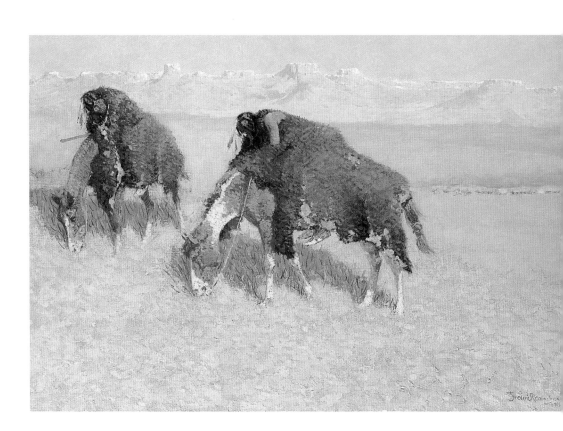

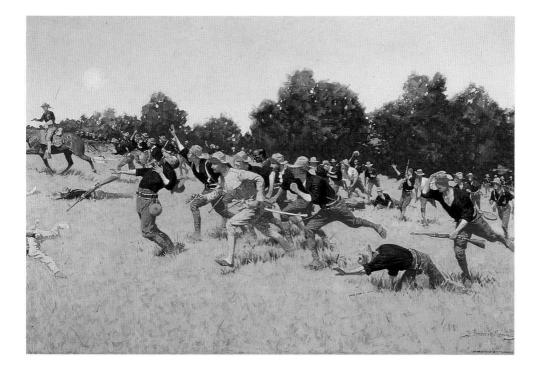

Charge of the Rough Riders at San Juan Hill

FREDERIC REMINGTON

1898, oil on canvas. Remington Art Museum, Ogdensburg, New York. Though recruited as cavalry, Teddy Roosevelt's famed Rough Riders, through a bureaucratic snafu, arrived in Cuba without horseflesh— hence the pedestrian charge.

micians, this was forever denied him. It was to prove a sore point throughout his life.

On the other hand, Frederic had become a social lion. Usually without his wife, he attended affairs at the Union League and other Manhattan clubs and hobnobbed with such figures as the architect Stanford White, the sculptor Augustus St. Gaudens, and the renowned illustrator Charles Dana Gibson. Remington was regarded as a legendary trencherman, capable, as a contemporary said, of "eating for two and drinking for four."

Seemingly fearless, Remington further displeased the membership committee of the National Academy with a bold display of his work. Angered that, a year previous, they had hung his entry in an obscure location, in 1893 the painter sent them nothing. Instead, he mounted his own exhibition of one hundred pictures. Sales totaled $7,300, more than many other artists of the Academy made in a year.

Then he was off again, this time to Mexico and California acquiring ideas and images for *Harper's* articles. On the Yellowstone he met the rising young fiction writer Owen Wister, later author of *The Virginian*, and began a collaboration, both at

Harper's and other publications, that would extend for a number of years.

Though still busy painting and traveling the artist found time to invent and patent a new type of military ammunition carrier. The army did not buy it. But the public bought *Pony Tracks*, his first book. Written and illustrated by the artist, it went into four printings and secured Frederic's reputation as a commentator on western life.

Yet Remington yearned for something else. He needed a war, and Spain provided it. By 1896 the Spanish colony of Cuba was embroiled in a protracted civil war with native guerrillas, who were holding much of the countryside. Remington teamed up with the noted war correspondent Richard Harding Davis to visit General Gomez, the rebel leader. Experiencing various delays and mishaps, they never got there, settling instead for a few weeks with the Spanish government in Havana.

However, the artist got his chance to experience battle conditions in 1898 when destruction of the battleship *Maine* propelled the United States into all-out war with Spain. When the American invasion fleet sailed for Cuba in June of that year Remington was aboard under the sponsorship of his old patron General Miles. It was not a pleasant

**Hauling in
the Gill Net**

FREDERIC REMINGTON

n.d., oil on canvas.

Remington Art Museum,

Ogdensburg, New York.

This atypical seascape
was probably painted
as an illustration. In
its tone and composition
it has a certain resem-
blance to the work
of Winslow Homer.

experience for him. He was ill and half starved
most of the time, dodging bullets on the approaches
to San Juan Hill and, worst of all, snubbed by rival
correspondents and their military sponsors.

By July Remington was back in New York, where
he wrote and illustrated an article for *Harper's
Monthly*. Far from the bombast one might have
expected, it was a candid recounting of the
errors, tragedies, and misery of war that one
critic suggested should be required reading for
"every prospective journalist . . . if he wants to
know the reverse side of the picture which al-
lures so many men." Remington himself was
through with war.

In 1899 Remington finally parted company with
Harper Brothers. The firm was in financial trou-
ble and, in addition, no longer gave him the top
billing he wanted. He switched to a rising literary
star, *Collier's Weekly*, which sent him back to
Cuba to do an illustrated article on the American
occupation army. This time things went better.

He stayed in a good hotel and dined with the
Governor General.

Twilight Years

The year 1900 was a memorable one. Remington
was given an honorary degree by Yale, and in May
he bought Ingleneuk, a house in the Thousand
Islands region of New York. Both Frederic and Eva
loved Ingleneuk, and from then on they spent the
summer months there with the artist doing a num-
ber of forest and Adirondack scenes, a relatively
neglected portion of his prodigious output.

In 1901 Remington turned forty. Though he saw
life now as "a down hill pull" and continued to be
afflicted with various ailments—most associated
with his obesity and indulgences—he was working
as hard as ever. His paintings, especially his night
scenes, became more impressionistic and his
color sense grew stronger. The canvases fre-
quently displayed emotional resonances lacking in
earlier works.

In 1901, too, Roosevelt became President. He not only regarded Remington as America's most important painter but he also willingly listened to the artist's advice on matters pertaining to the military. It is doubtful that any other American artist has had such influence on public policy.

By 1902 Remington had withdrawn almost entirely from the field of illustration. He had turned his hand to sculpture in the mid '90s and found it to be a highly successful artistic venture. He did not need money, and by now he wanted merely to be seen as an active and inspired sculptor and fine artist. In fact, on various occasions over the next few years he burned the originals of some of his most famous illustrations, paintings which he would once have regarded as ready money. He also began to think about buying land along the Connecticut River where several of his friends summered—including the painters J. Alden Weir, Edmund Tarbell, and John Twachtman, members of the American Impressionist group with which he was becoming associated.

In 1906, Remington's show at the prestigious Knoedler Gallery in Manhattan was hailed by no less than the celebrated Childe Hassam as "all the best things—nobody else can do them. . . ."

It was in the fall of this year that Remington, now forty-seven, made his last jaunt West, an abortive hunting trip to Wyoming. It lasted only three weeks and he returned exhausted and ill. His rambling days were over.

A Triumph to the End

The year did end on a triumphant note, however, with a December show at Knoedler's garnering universal critical praise and receipts of $8,500. Frederic was now able to start building the Ridgefield, Connecticut, house. Then, in quick succession, Ingleneuk and the New Rochelle house were sold. In May of 1909 he and Eva moved to their newly finished home.

That year the artist learned that one of his paintings had been purchased for Washington's National Museum. Yet while he enjoyed the companionship and respect of his artist friends he was continually plagued by rheumatism, being, in fact, too crippled to attend the December opening of his third one-man show at Knoedler. Despite his absence, this was a great success, with six of the seventeen paintings selling on the first day.

On December 20, 1909, Remington noted sharp stomach pains. He tried ignoring them, then administered self-medication—a harsh purgative. By the time a doctor was summoned his appendix had burst, and an operation revealed extensive peritonitis. On the 26th, at the height of his powers and reputation, Frederic Remington was dead.

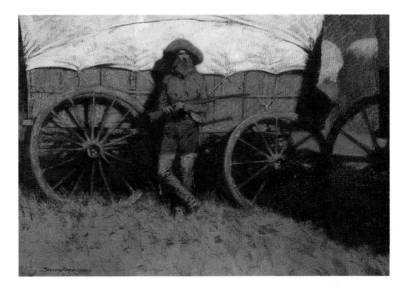

The Sentinel

FREDERIC REMINGTON

1907, oil on canvas. Remington Art Museum, Ogdensburg, New York.

One of Remington's famous night studies, this work depicts a grizzled plainsman guarding a darkened wagon train.

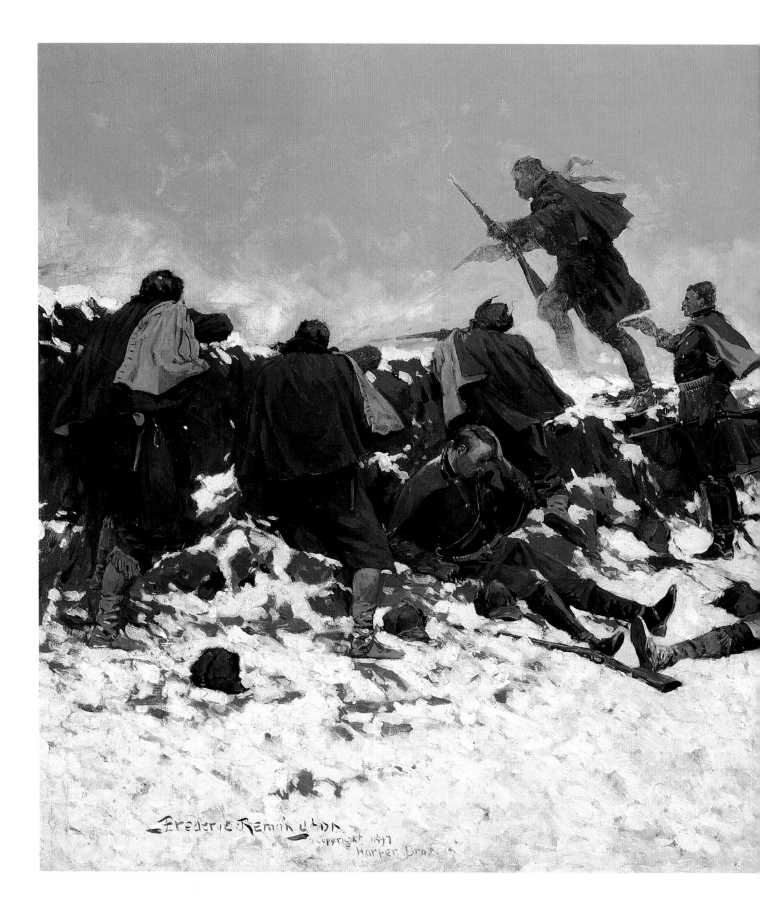

Frederic Remington
Copyright 1897
Harper Bros.

**Through the Smoke
Sprang the Daring
Young Soldier**

FREDERIC REMINGTON

*1897, oil on canvas. Amon Carter
Museum, Fort Worth, Texas.*
Though seemingly heroic,
the incident depicted here
was part of a shameless
slaughter of the Cheyenne,
which even the artist was
forced to admit was nothing
but "a bushwacking."

Small Oaks

FREDERIC REMINGTON

1887, oil on canvas. Remington Art Museum, Ogdensburg, New York.
This bucolic camping scene with pitched tent, beds, table,
and even a rocking chair reflects the comfortable Adiron-
dack-style camping favored by the artist and his wife.

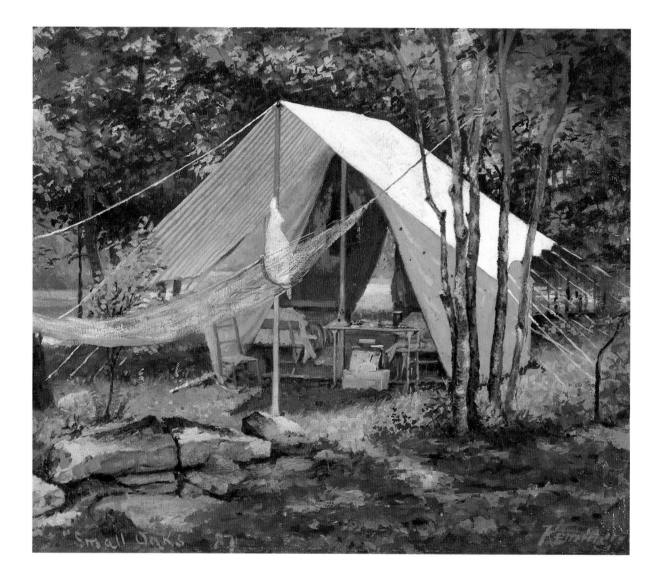

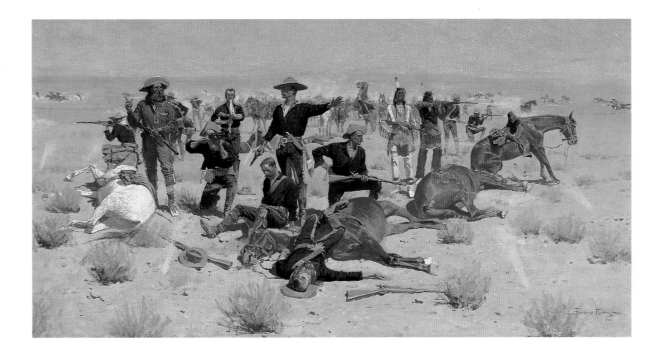

Rounded-Up

FREDERIC REMINGTON

1901, oil on canvas. Sid Richardson

Collection of Western Art, Fort Worth, Texas.

The encircled band of outnumbered troopers, hunters, or settlers was one of Remington's favorite themes. This rather cluttered example should be compared with the artist's more sophisticated treatment of the topic in *The Fight for the Waterhole* (1901).

FOLLOWING PAGE:

Dismounted: The Fourth Trooper Moving the Led Horses

FREDERIC REMINGTON

1890, oil on canvas. Sterling and Francine Clark Art Institute, Williamstown, Massachusetts.

Though they customarily fought on horseback, it was not unusual for cavalrymen to dismount and defend a fixed position while their horses were led to shelter.

FREDERIC REMINGTON
1890

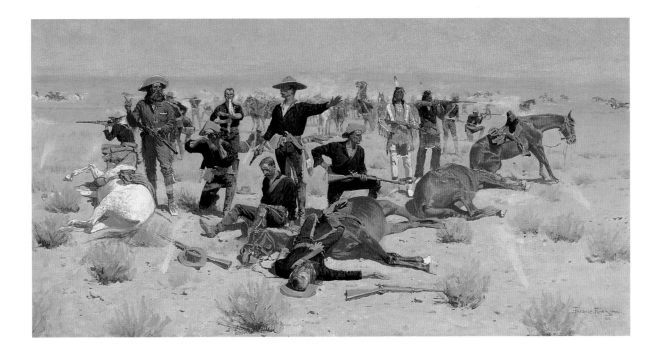

Rounded-Up

FREDERIC REMINGTON

1901, oil on canvas. Sid Richardson

Collection of Western Art, Fort Worth, Texas.

The encircled band of outnumbered troopers, hunters, or settlers was one of Remington's favorite themes. This rather cluttered example should be compared with the artist's more sophisticated treatment of the topic in *The Fight for the Waterhole* (1901).

FOLLOWING PAGE:

Dismounted: The Fourth Trooper Moving the Led Horses

FREDERIC REMINGTON

1890, oil on canvas. Sterling and Francine Clark Art Institute, Williamstown, Massachusetts.

Though they customarily fought on horseback, it was not unusual for cavalrymen to dismount and defend a fixed position while their horses were led to shelter.

FREDERIC REMINGTON
1890

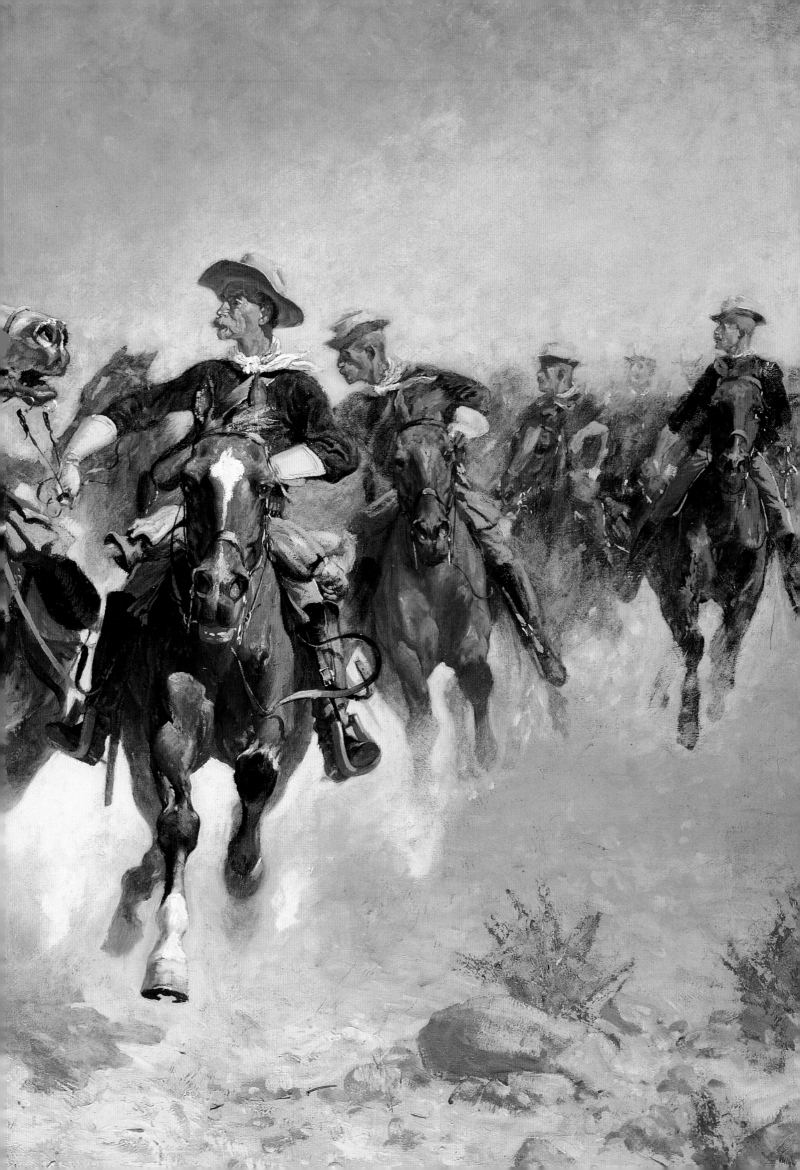

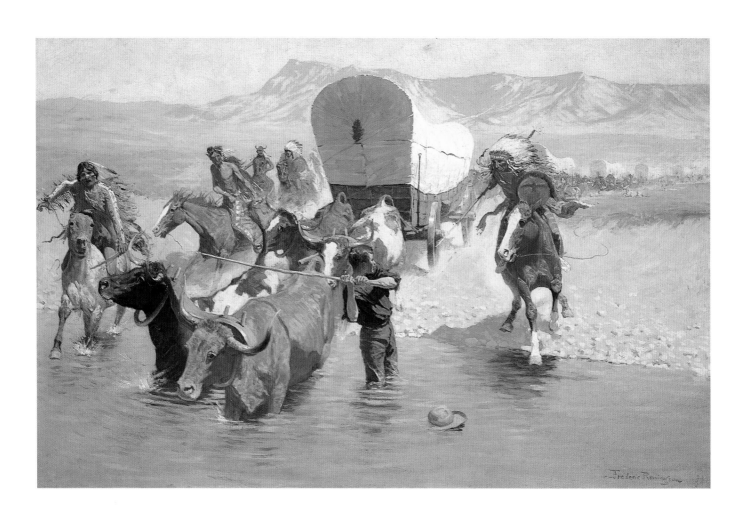

The Emigrants

FREDERIC REMINGTON

1904, oil on canvas. Museum of Fine Arts, Houston, Texas.

While Indian attacks on large wagon trains were relatively
uncommon, pictures like this one fed a public belief that anyone
traveling west of St. Louis was in imminent danger of losing his or her hair.

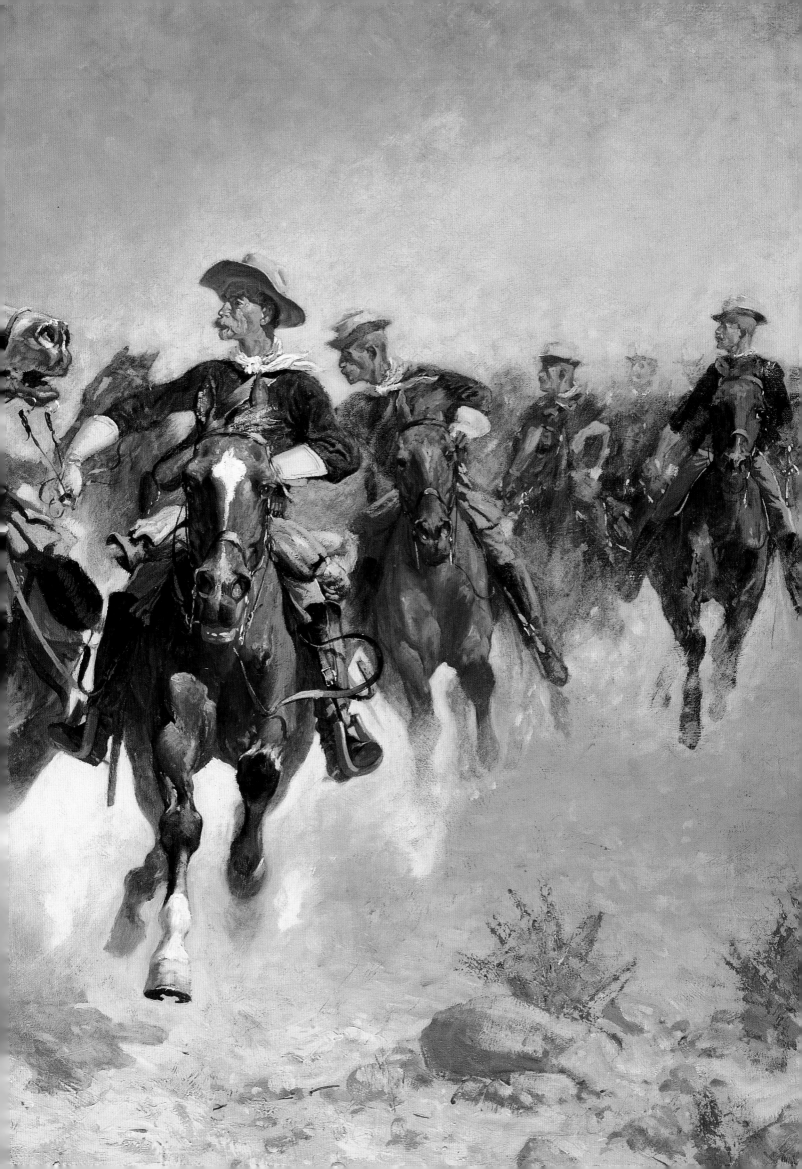

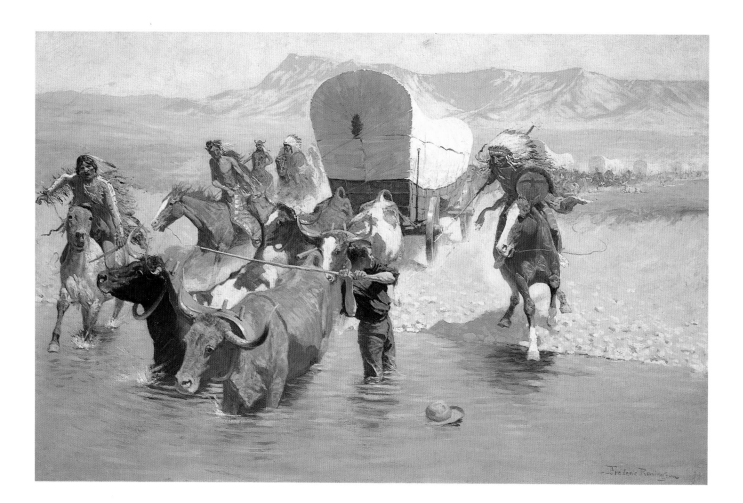

The Emigrants

FREDERIC REMINGTON

1904, oil on canvas. Museum of Fine Arts, Houston, Texas.

While Indian attacks on large wagon trains were relatively
uncommon, pictures like this one fed a public belief that anyone
traveling west of St. Louis was in imminent danger of losing his or her hair.

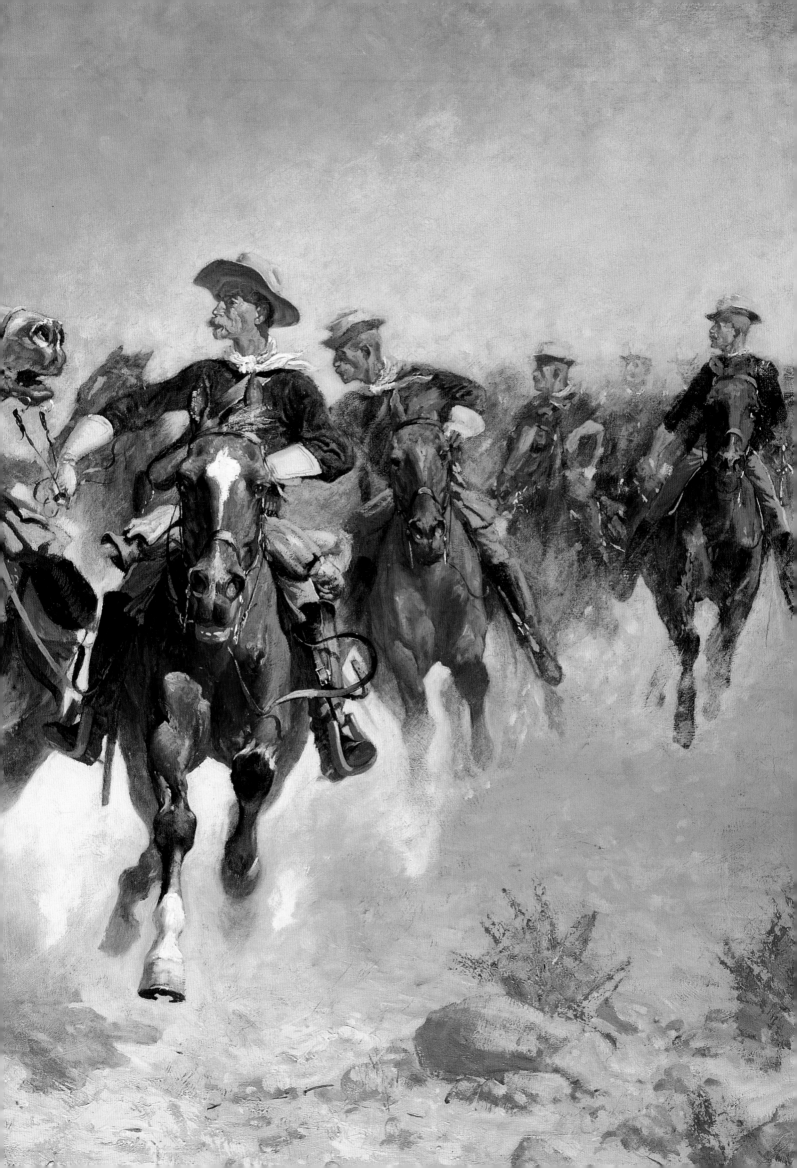

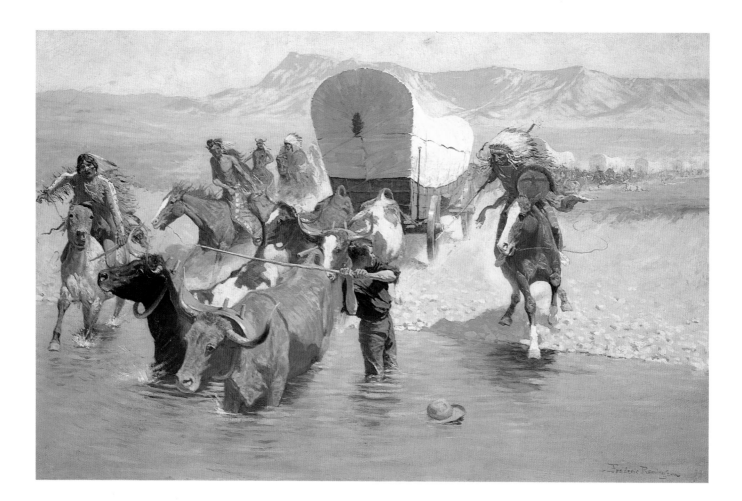

The Emigrants

FREDERIC REMINGTON

1904, oil on canvas. Museum of Fine Arts, Houston, Texas.

While Indian attacks on large wagon trains were relatively
uncommon, pictures like this one fed a public belief that anyone
traveling west of St. Louis was in imminent danger of losing his or her hair.

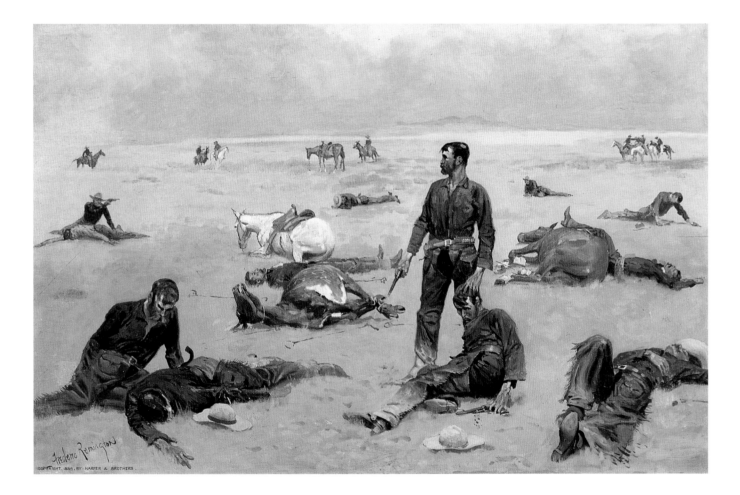

What An Unbranded Cow Has Cost

FREDERIC REMINGTON

1895, oil on canvas. Yale University Art Gallery, New Haven, Connecticut.

While disputes over the ownership of unbranded cows
seldom led to such mayhem, the wise cowboy was careful
about whose beast he was putting his mark on.

Prospecting for Cattle Range

FREDERIC REMINGTON

c. 1889, oil on canvas. Buffalo Bill Historical Center, Cody, Wyoming.
In the days before the plains were fenced and farmed, cowhands like these two would scout out new range with fresh grass for their wandering herds.

Cavalry in an Arizona Sandstorm

FREDERIC REMINGTON

1889, oil on canvas. Amon Carter Museum, Fort Worth, Texas.
Remington depicted his beloved horse soldiers in a variety of positions but rarely in combat with nature, as here, a more persistent enemy in fact than the Indian.

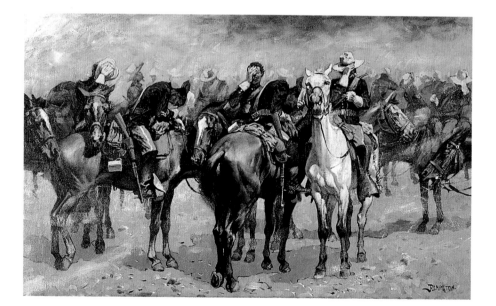

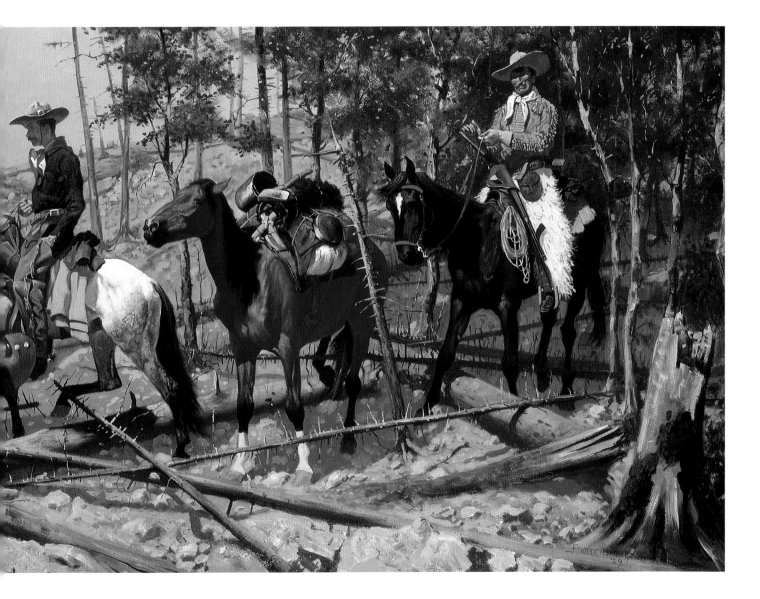

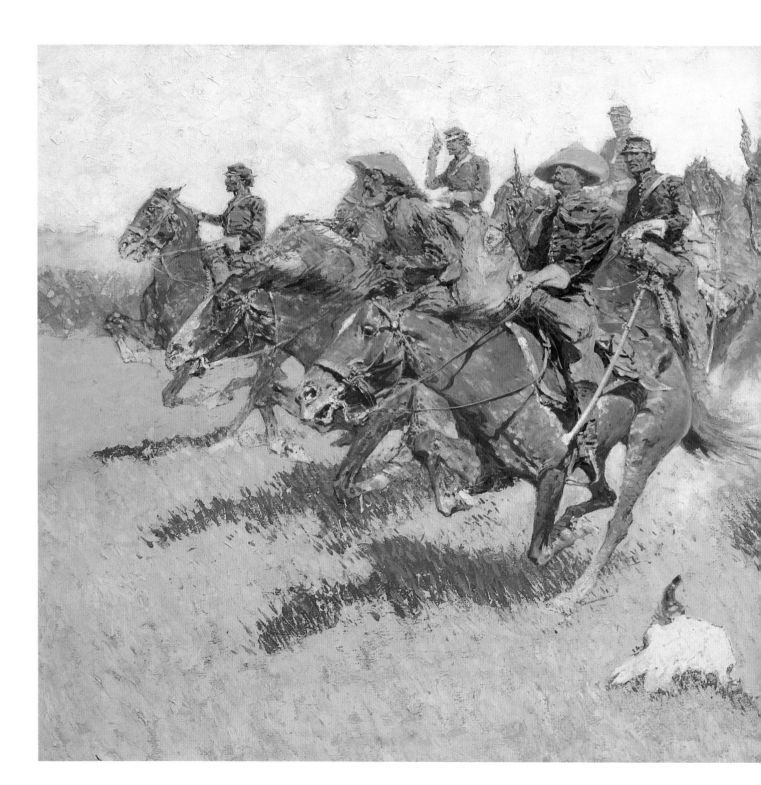

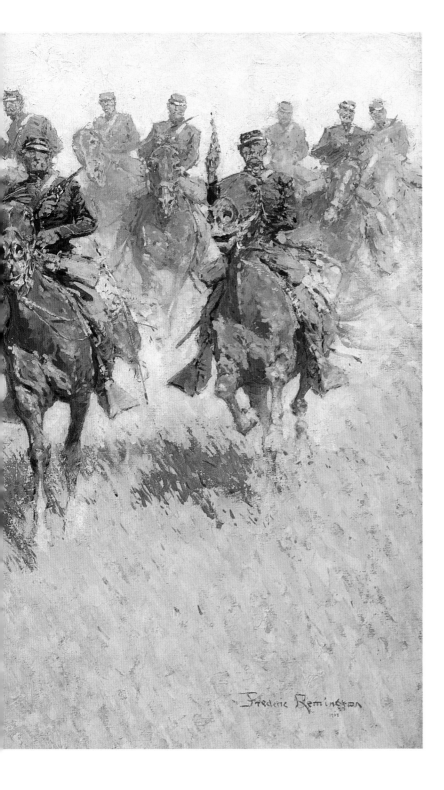

On the Southern Plains

FREDERIC REMINGTON
1907, oil on canvas.
Gift of Several Gentlemen,
1911, The Metropolitan
Museum of Art, New York.
In yet another paean
to his beloved horse
soldiers, Remington
here captures a cavalry
troop as, pistols in
hand, they sweep
down on the enemy.

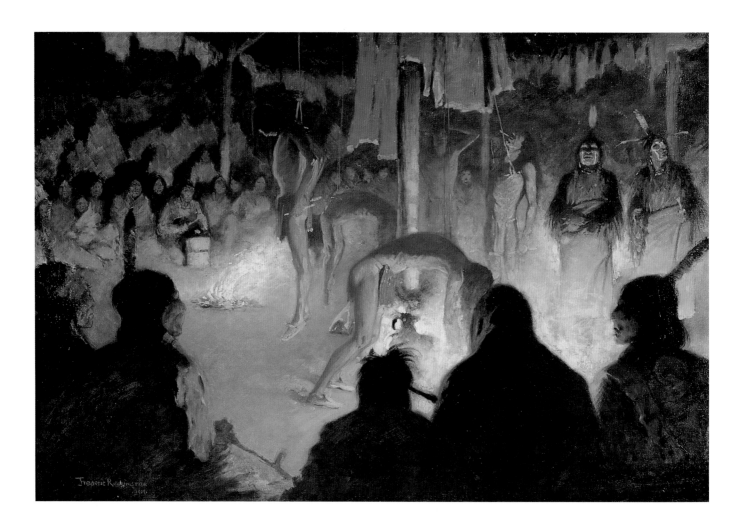

The Sun Dance

FREDERIC REMINGTON

1890, oil on canvas. Remington Art Museum, Ogdensburg, New York.

Unlike some earlier artists such as George Catlin, Remington never
witnessed this Plains Indians' measure of courage. However, the
details were well enough known at the time for him to accurately depict it.

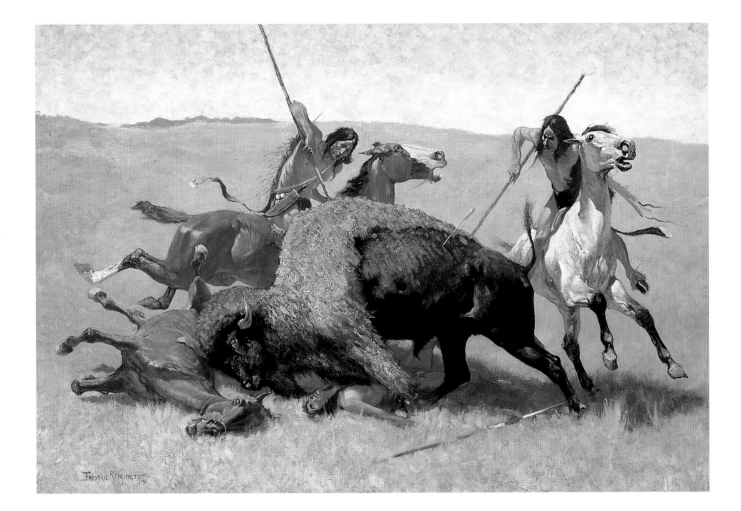

The Buffalo Hunt

FREDERIC REMINGTON

1890, oil on canvas. Buffalo Bill Historical Center, Cody, Wyoming.

Though relatively slow and not particularly bright,
the cornered bison could be ferocious—as illustrated
in this violent encounter with Indian hunters.

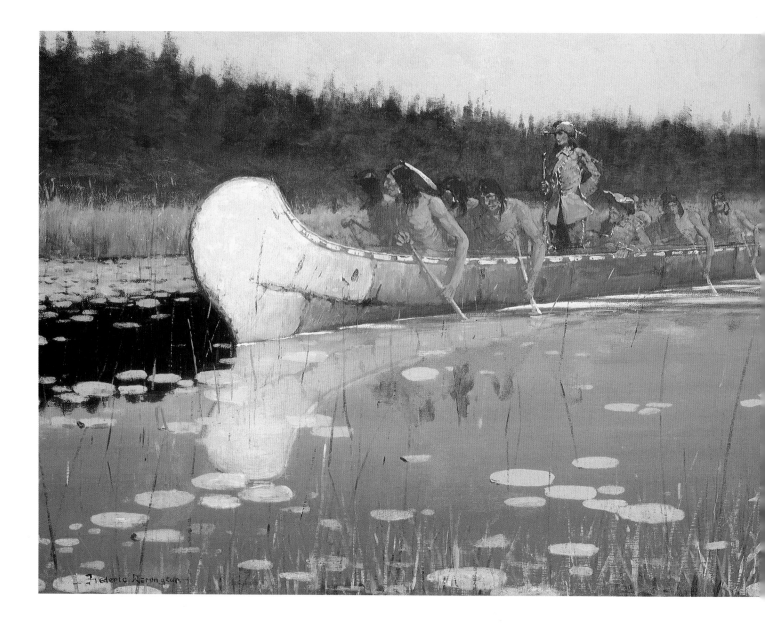

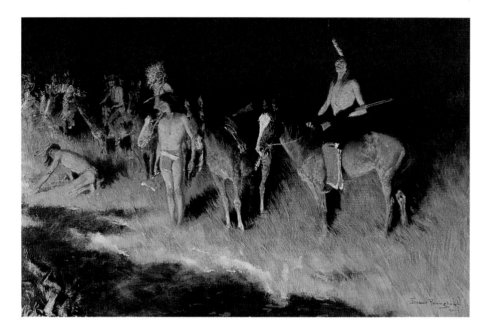

The Grass Fire
FREDERIC REMINGTON

1908, oil on canvas. Amon Carter Museum, Fort Worth, Texas.
Native Americans sometimes set fires to drive buffalo
and also as a weapon of war, advancing toward their
blinded and frightened enemy under cover of smoke.

Radisson and Groseilliers
FREDERIC REMINGTON

1905, oil on canvas. Buffalo Bill Historical Center, Cody, Wyoming.
Late in his career, Remington was asked to do an illust-
rated series on early explorers of North America. This
picture of French voyageurs is representative of the type.

THE FIGHTING CHEYENNES

The Red man was the true American
They have almost gon. but will never
be forgotten
The history of how they faught for
their county is written in blood
a stain that time cannot grinde
out
their God was the sun their Church
all out doors their only book
was nature and they knew all
its pages
 C M Russell

Artists and Writers

In addition to being painters and illustrators, both Charlie Russell and Frederic Remington wrote extensively. Remington, of course, was raised in a literary family. His father had been a newspaper editor, publisher, and owner, and the artist had initially considered a career in journalism. It was, therefore, natural that he should gravitate toward the field. Russell had no such antecedents, and there is no indication that he had ever thought of himself as a professional writer.

Russell's Colorful Letters

Interestingly, though, while much of Remington's writing is today all but forgotten, Russell's remains popular, primarily due to the survival of his illustrated letters. The earliest of these, to "Friend Pony" (another cow hand), dates to 1887 and contains no less than twenty-two pen-and-ink sketches of range scenes, some relating to the terrible winter kill of cattle that occurred in 1886–87. It also includes some frank comments on his early artistic aspirations:

The Fighting Cheyennes

CHARLES M. RUSSELL

1916, illustrated note, pen and ink.

Buffalo Bill Historical Center, Cody, Wyoming.

Typical of his affection for Native Americans, Russell here wrote: "The Red Man was the true American. They have almost gon [sic], but will never be forgotten . . ."

I have tried several times to make a living painting but could not make it stick and had to go back to the range. I expect I will have to ride till the end of my days but I would rather be a poor cow puncher than a poor artist.

Russell continued throughout his life to write illustrated letters to friends and relatives with no apparent thought of their value as either art or literature. He also provided some letters with elaborately illustrated envelopes. Understandably, few of these letters and envelopes were discarded by the recipients, and most remained for years in private collections.

These missives were almost always written in a fractured English or "Injun" dialect that some have taken to be a reflection of Russell's lack of schooling. It is more likely, however, that the artist regarded this more as a matter of style; that he could write in a very different manner is evident from the following quotations. The first, in nearly incomprehensible jargon, is from a letter of July 28, 1907, to Johnny Matheson, a longtime friend and western freight driver:

How good Fren
Me get its saddle dats a be Dam good one
but you don't said how much
When I get it little people make me heap glad
One there maybe so for squaw little
Injun ride hoss make me laugh
Heap good

Illustrated Letter to G. W. Farr

CHARLES M. RUSSELL

1919, pen and ink on paper. Montana Historical Society, Helena, Montana.

Illustrated with a picture of a cowboy driving stock, this brief nostalgic note refers to the artist's old companions: " . . . many of them have crossed the big range, but they left tracks in history that the farmer can't plow under"

The second, very different in style, and dated April 24, 1911, is to a potential buyer of one of his paintings:

> The Medicine Man I consider one of the best pieces of my work and these few words may give you some idea of the meaning of the picture. The medicine man among the plains Indians often had more to do with the movements of his people than the Chief . . .

It is evident, through comparison of his letters and other writings, that Charlie wrote in several styles and dialects to suit the occasion and for the amusement of his readers. Frederic Remington, who had far more formal education, did much the same but for different reasons.

Cowboy Poet

Russell was also a poet—a rather minor one—who adorned his greeting cards with doggerel such as this:

> Best wishes for your Christmas
> Is all you get from me,
> 'Cause I ain't no Santa Claus—
> Don't own no Christmas tree.
> But if wishes was health and money,
> I'd fill your buck-skin poke,
> Your doctor would go hungry
> An' you never would be broke.

Rawhide Rawlins

There was no doubt that Charlie was a born storyteller, and his lengthy, humorous letters were a natural extension of this talent. Many of these, gathered together by his wife following Russell's death, were published in 1929 under the title *Good Medicine*. A more complete collection, titled *Paper Talk: Charlie Russell's American West*, is the current standard reference.

Russell's talent for spinning the tall tale (Will Rogers, no mean talker himself, said flat out that "I never met a person yet that ever heard him that didn't say he was the greatest storyteller they ever listened to.") led eventually to the *Rawhide Rawlins Stories*. The first of these, published in 1921, combined Charlie's pen-and-ink illustrations and his own stories, offered through the mouth of the fictitious cowboy he called Rawhide Rawlins.

The tales Charlie and other cowboys and "oldtimers" told combined traditional folklore handed down from generation to generation with stylized versions of actual events. western life, at the turn of the century, could be full of unexpected happenings, not all of them pleasant, but the typical Rawhide tale rarely dwelt on the morbid aspects. Even when his hero was in difficulty, Charlie found something funny in the situation.

This first book proved sufficiently popular that Russell published a second collection, *More*

Will Rogers

CHARLES M. RUSSELL

n.d., bronze. Amon Carter Museum, Fort Worth, Texas.

Rogers and Russell were good friends, each regarding the other as "the greatest storyteller there ever was." In fact, it was a close contest, perhaps a draw.

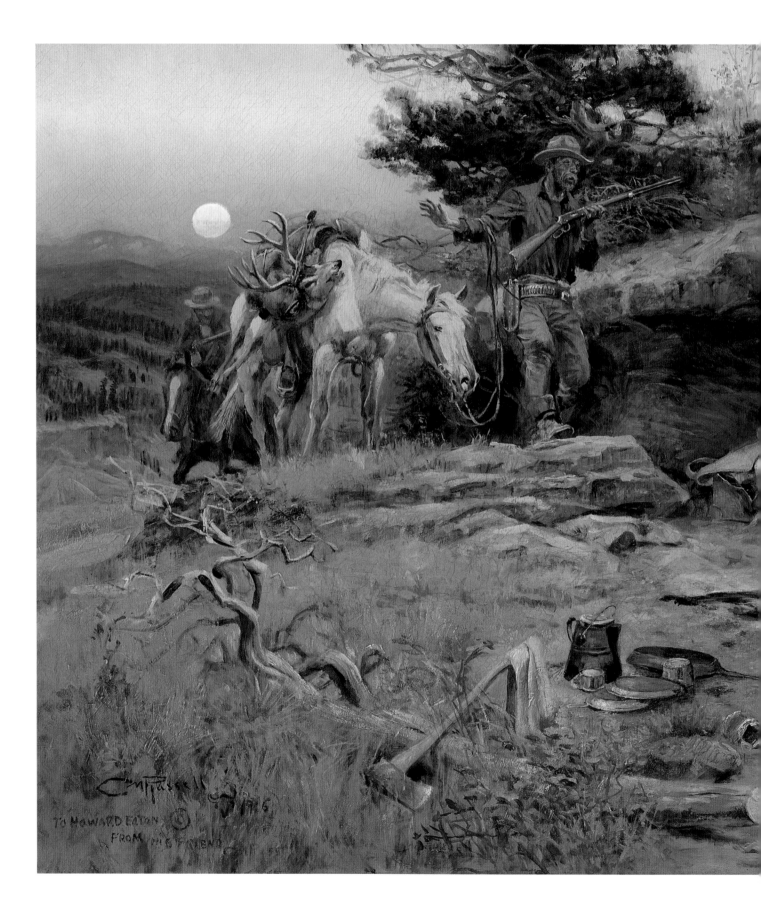

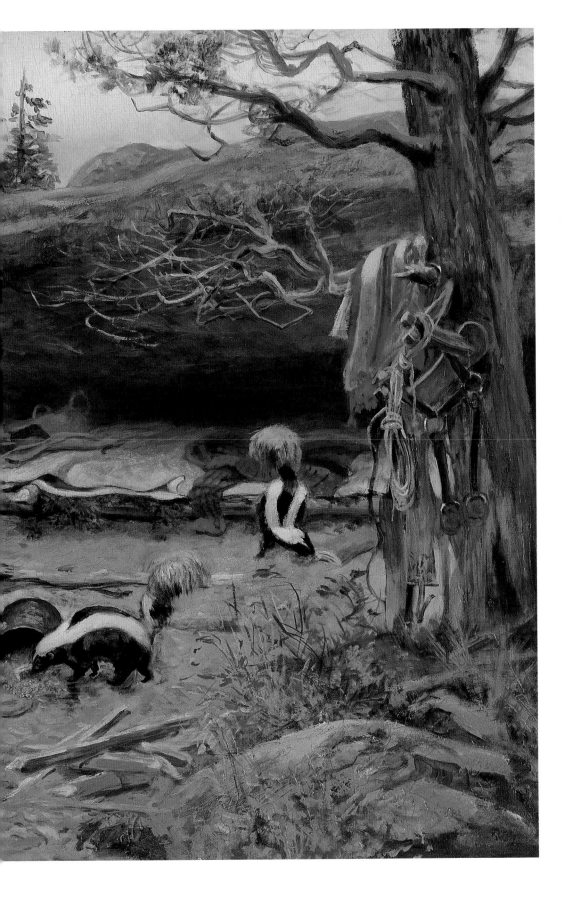

**Man's Weapons
are Useless
When Nature
Goes Armed
(Weapons of
the Weak; Two
of a Kind Win)**

CHARLES M. RUSSELL

1916, oil on canvas.

Sid Richardson

Collection of Western

Art, Fort Worth, Texas.

A fine example of the

artist's sense of humor,

this illustration of

hunters ambushed

by skunks will bring

a smile of recognition

to many campers.

n.d., pen and ink on paper. The Wichita Art Museum, Wichita, Kansas.
Russell, who wrote his own poetry, sometimes illustrated
the work of other poets, as in this humorous version
of a "Saturday night out" in a western cow town.

They danced and they drank, and they sang that old song,
"I'm just a poor cow-boy, and know I've done wrong,"
While the click of the chips in the games that were played,
And the sob in the music the violin made
Rang out through the smoke that clouded the room,
For Joy held the top-hand and drink drowned all gloom
The future might hold for him who made gay,—
And life filled with sunbeams, when Shorty would say
"What's yours, Pard?"

Rawhides, which was published in 1925. A
Montana journalist speculated on why the artist
had tried his hand at literature:

Just why Charlie Russell turns to writing is prob-
lematical, having triumphed in the other arts to an
extent which keeps him a very busy man. It seems
to be Russell's supplementary message to accom-
pany the work of his brush; to show the world that
he knew and lived the life he painted.

This may be true to some extent but for Charlie
(who did not have to prove his unquestioned west-
ern heritage) it seems more likely that his books
were a natural outgrowth of his storytelling and,
especially, his illustrated letters.

It was somewhat different for Frederic Remington
who, aware of his limited living experience in the
West, to some extent employed both frontier tales
and pseudo-western dialect to bolster his claims
to authentic knowledge of the region.

Remington was not a cowboy. He was
an educated upper-middle-class East-
erner who visited western locales to
obtain material for his art. At a very
early period, however, he found it nec-
essary to supplement his illustrations
with text, due to the fact that staff writ-
ers at the publications for which he
worked had never been West and had no
idea of how life was actually lived there.

In fact his second published illustra-
tion, "Ejecting an Oklahoma Boomer,"
published by *Harper's* in 1884, was
accompanied by explanatory text.
Though this was redone by a staff
writer it may correctly be said to be the
beginning of Frederic's literary career.

The artist was quick to see that it
was financially beneficial to write as
well as to illustrate. After all, his arti-
cles had to be illustrated so this fact
added more commissions to those ob-
tained for other authors' work. By 1894
Remington was writing fully a third of
the pieces which he illustrated.

Not everyone in the field was
pleased with this. A Manhattan jour-
nalist complained that:

. . . there is a growing propensity of the contempo-
rary illustrator to do two men's work. Time was
when illustrators looked upon authors with respect
. . . But, alas! through continued association with
writers, the illustrators learned to spell. Mr.
Remington does not scruple to garnish his horse-
flesh with narratives of adventure.

Remington, of course, was not one to be de-
terred by such criticism. He continued to compete
more and more with established writers, and par-
ticularly war correspondents, writing his own il-
lustrated articles on the late Indian Wars and the
conflict in Cuba.

The Writer's Life

Despite the carping, the artist proved to be a good writer. One biographer has called his works "precursors of the American realists of the 1920s." Unlike the Victorian style, his was direct, down to earth, loaded with detail, and often quite bloody. A contemporary critic hailed its "close-packed simplicity and clear descriptive statement." Dialect, where introduced at all, was applied for effect: Remington, in fact, was more likely to employ it in his (unillustrated) personal letters where he wished to impress the recipient with his "Westernness."

Given the enthusiastic public response to his articles, it is not surprising that the artist turned to bigger things. In 1895, an anthology of his previously published work, titled *Pony Tracks*, was published, and the book was generally well received, one critic noting that "it provided a better idea of army life on the western border than all the official records." *Pony Tracks* established Remington as an author.

A year later his *Drawings*, a picture book containing both original art and previously published works—with a foreword by Owen Wister, author of

The Virginian—was released. This venture into the world of "coffee table" literature was not so successful. The book sold slowly and, worse yet, a fly-by-night Chicago publisher pirated many of the illustrations.

A second anthology of articles written for the Harper's firm, *Men With The Bark On*, published in 1900, met with greater success. It reflected the author's post–Spanish American War point of view, less bold and bellicose, more aware of life's fragility. Readers were apparently ready for a book where "helplessness and tragedy replace glory and heroism"; it was reprinted twice in just two months.

Frederic, though, was already at work on something new, a novel on Native American life, titled *The Way of an Indian*. Various problems with publication delayed this book (it was not to see the light of day until 1905), so Remington pushed on to other projects—two more picture books, and then a second novel, *John Ermine of the Yellowstone*, published in 1902.

It is interesting that Remington, who had generally supported a military solution to the "Indian problem," should choose for his only novels two

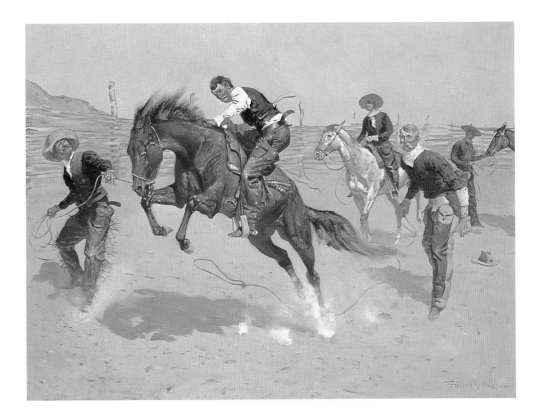

"Turn Him Loose, Bill"

FREDERIC REMINGTON
1892, oil on canvas.
The Anschutz Collection,
Denver, Colorado.
Remington prided himself on dramatic and accurate representations of the horse, as displayed in this picture of a wild stallion being broken to the saddle.

stories about Indians, both of which pictured them in a generally favorable light. He was not unique, though: many Americans, now that the Native Americans were all dead or confined to reservations, felt suddenly nostalgic about them. There was a ready market for romanticized versions of Indian life.

Despite this seemingly eager audience and generally favorable reviews, both books showed only modest sales. Remington made about $4,000 in royalties on two editions of *The Way of An Indian*. *Ermine*, hailed by one critic as "perhaps the only successful attempt to give the psychology of the western Indian in his war and love-life," never attracted a wide audience.

To the Stage

John Ermine of the Yellowstone was, however, to have another life. Soon after it was in print, Remington's friend and associate Louis Shipman took an option on it for stage production, also enlisting in the project James K. Hackett, a leading Broadway actor and manager. Shipman wrote the stage script. Remington approved of it and added his own suggestions for costumes.

Frederic loved the stage (he and his wife attended the theater regularly), and he enjoyed his new association with the theatrical set. Thus he looked forward to production of his own play. Unfortunately, things did not go well. *Ermine* was written as a serious, tragic play. Hackett, a ham-handed thespian, turned it into a farce. The well-known theatrical expression "Bombed in Boston" applied to the tryout there, and when the play reappeared in Chicago for a second tryout, it had been greatly altered. There was now a happy ending to satisfy theatergoers with no stomach for tragedy.

The new *Ermine* opened on Broadway in November, 1903. It closed four weeks later. Though he blamed the public, declaring that they "don't want to know anything about the Indian or the half-breed, or what he thinks or believes," Remington knew in his heart that the absurd alterations to his text had doomed the play. In later years he failed to include either the book or the stage play in his biography.

After a modicum of success, and not from want

of trying, Frederic Remington declared himself to be "worn out" from his writing. By 1903 he focused more and more on sculpture and on the new impressionistic palette which was so greatly altering his painting. He was, for the most part, through with the world of literature.

Drum Corps, Mexican Army, 1889

FREDERIC REMINGTON

c. 1889, oil on wood. Amon Carter Museum, Fort Worth, Texas.

Remington's general disdain for the Mexican people was tempered, as
here, by his general fondness for the military of whatever nationality. This
painting was done as an illustration for Thomas Janvier's *The Mexican Army*.

Aug 25 1917

Friend Jim

I got a box of cantilope all so a big water melon . there was no name with them but Im a good guesser

Jim among moovies your not always a good picker But in a melion patch your a Judg and a Gentilman Iv been told that to read the good things in a melon through its hide must be learned in boy hoods happy hours if this is true judging from the quality of frute you sent us its a saf bet you got bird shot in your hide right now

As well as I know you Purk if I owned a patch of this water frute and I saw you in the naber hood right then when Id start night hearding my melons and Id hang a bell on the big ones

give my regards to the home gard for yourself at the sigar store hold som out with many thanks your friend C M Russell

Illustrated Letter to Jim Perkins

CHARLES M. RUSSELL

1917, ink and watercolor on paper.

Amon Carter Museum, Fort Worth, Texas.

This humorous representation
of boys fleeing a melon patch
accompanied a "thank you" note
to Perkins, who had sent the artist a
box of cantaloupes and watermelons.

Illustrated Letter to Sid Willis, April 20, 1914

CHARLES M. RUSSELL

1914, ink and watercolor on paper. Amon Carter Museum, Fort Worth, Texas.

While hardly a world traveler like Remington, Russell did go to
England and France in connection with an exhibit of his work,
prompting this humorous comment on English royal traditions.

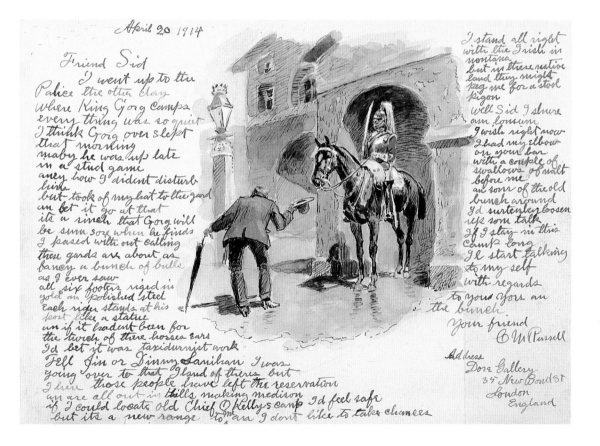

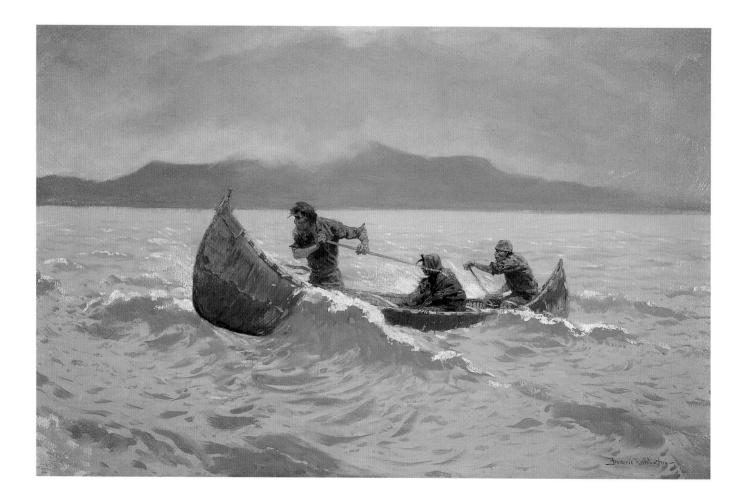

Howl of the Weather

FREDERIC REMINGTON

1906, oil on canvas. Remington Art Museum, Ogdensburg, New York.

One of a series of historical paintings dealing with
western exploration, this piece depicts several
voyageurs beating across a lake in a heavy squall.

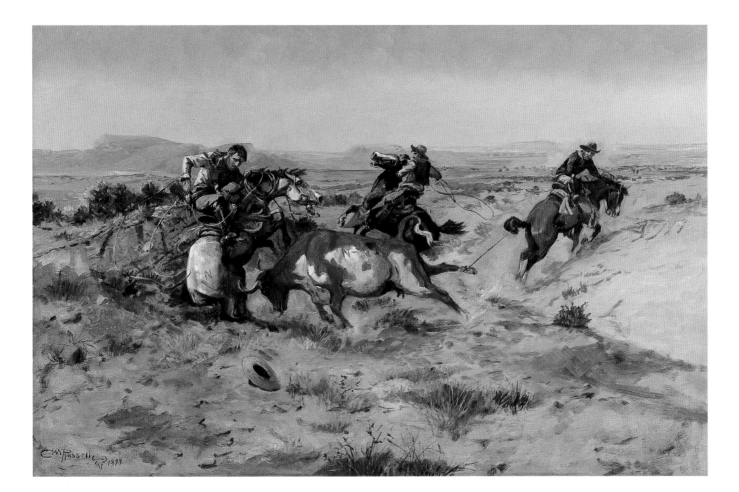

When Cowboys Get in Trouble

CHARLES M. RUSSELL

1899, oil on canvas. Sid Richardson Collection of Western Art, Fort Worth, Texas.

As a working cowpuncher, Russell himself may have experienced

the peril of facing an enraged longhorn, as depicted in this work.

Certainly, the painter had observed such dangerous encounters.

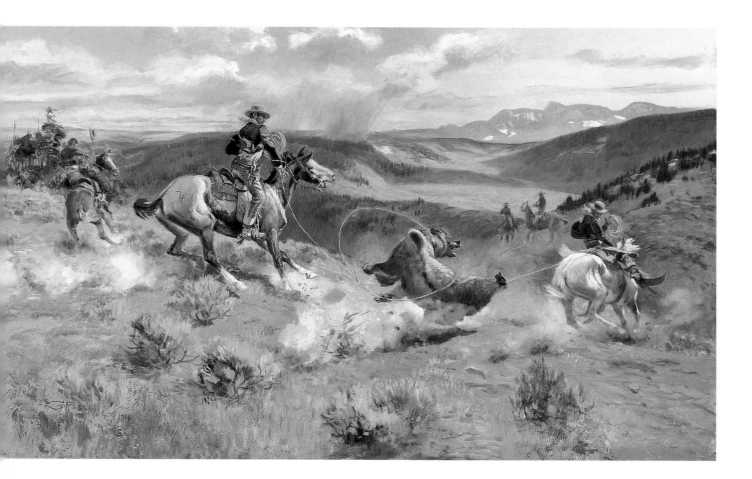

Loops and Swift Horses are Surer than Lead

CHARLES M. RUSSELL

1916, oil on canvas. Amon Carter Museum, Fort Worth, Texas.

This painting is based on one of Russell's own
tales—the story of a group of unarmed cowboys
who, encountering a grizzly on the open plains,
ran it down, roped it, and stoned it to death.

The Cowboy

FREDERIC REMINGTON

1902, oil on canvas. Amon Carter Museum, Fort Worth, Texas.

This depiction of a cowhand herding wild horses was pub-
lished in *Scribner's* magazine in October of 1902. It is one
of the most frequently reproduced of the artist's works.

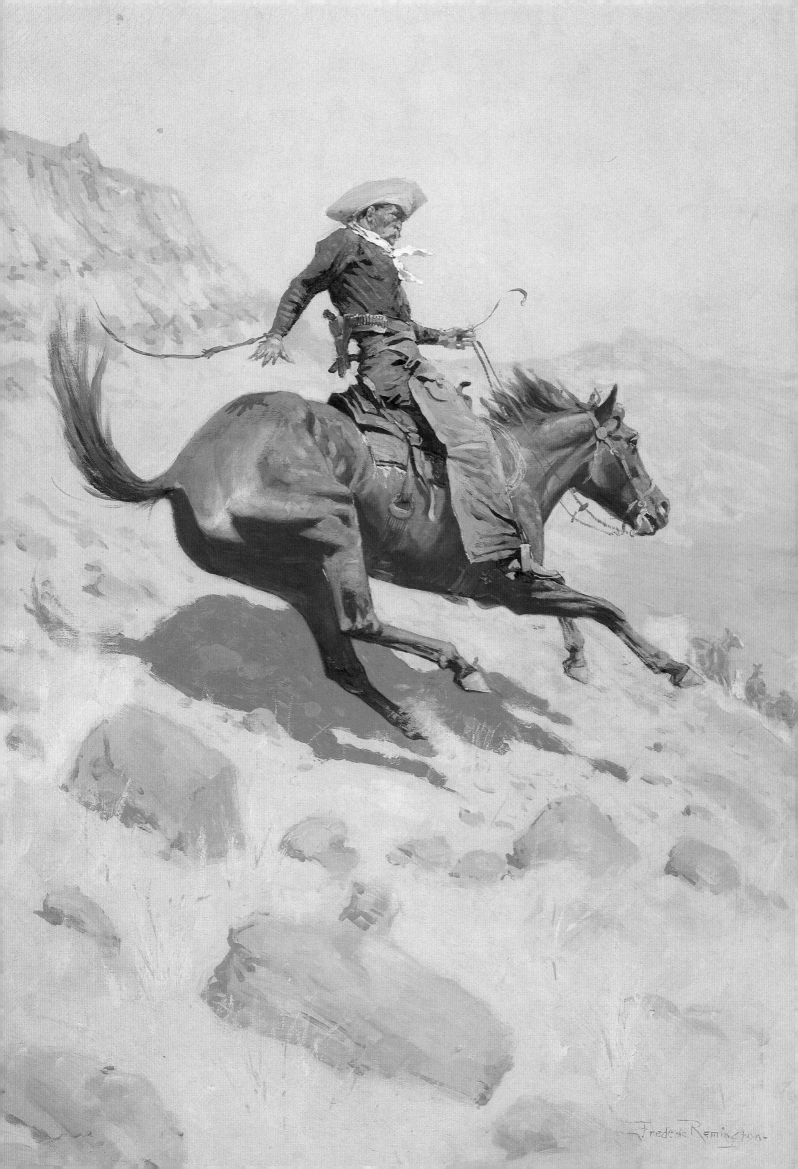

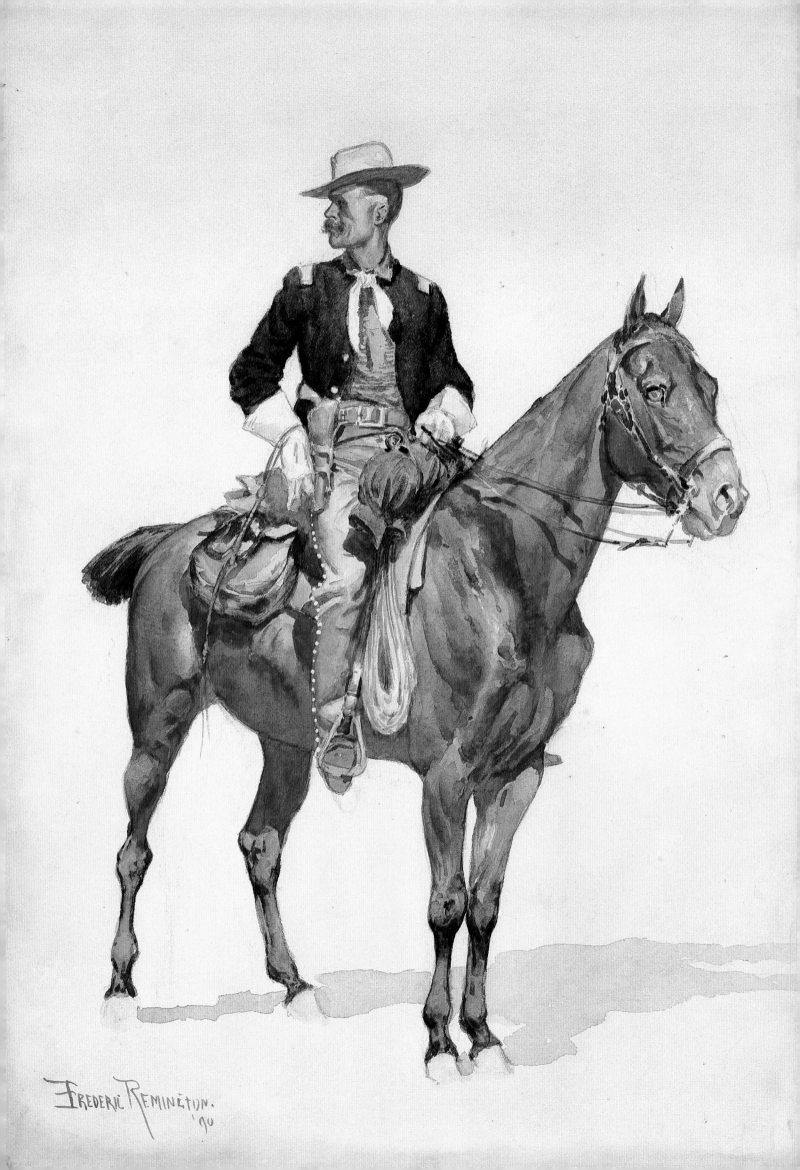

FREDERIC REMINGTON.
'90

CHAPTER FOUR

The Painters and Their Technique

Both Charles M. Russell and Frederic Remington were extremely prolific artists. Remington is credited with over 4,700 works and Russell's total output is probably comparable, though uncertain due to the loss of so many early pieces.

Both had limited academic training and both were highly observant artists keenly concerned with accuracy of details, color, and period. However, they differed as painters in many respects as well. Russell was always an illustrator, whose work told a story. Remington started out that way but, influenced by contact with the American Impressionist school, he gradually abandoned the literal for the suggestive. On the other hand as sculptors, from their very first work, both artists showed the ability to combine a profound knowledge and expression of human and animal form and movement with a classic yet impressionistic approach that lay far ahead of most of their contemporaries.

Remington was highly verbal and well schooled in New York "art talk." His work, produced in the metropolis, was also subjected to critical scrutiny, and written analysis of it is readily available. Russell, on the other hand, had little to say about his technique and because he was well removed from the major artistic centers, at least until late in his career, he was able to avoid running the tastemakers' gauntlet.

Lieutenant S. C. Robertson, Chief of the Crow Scouts

FREDERIC REMINGTON

1890, watercolor on paper. Amon Carter Museum, Fort Worth, Texas.

Robertson, one of the artist's many friends in the cavalry, trained Crow Indians to be irregular cavalry and scouts. The portrait is one of several Remington painted of western acquaintances.

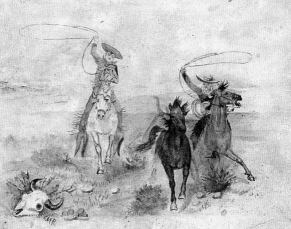

Ropin 'Em

CHARLES M. RUSSELL

c. 1883, watercolor on cardboard. Amon Carter Museum, Fort Worth, Texas.

One of Russell's earliest known paintings, this relatively crude work should be compared with the artist's masterly examples of the early twentieth century.

Buffalo Bill's Duel with Yellowhand

CHARLES M. RUSSELL

1917, oil on canvas. Sid Richardson

Collection of Western Art, Fort Worth, Texas.

This confrontation between the legendary scout
and showman and a Cheyenne sub-chief, as portrayed
by the well-known western painter, supposedly took
place a few weeks after the battle of Little Big Horn.

Also, where Remington's artistic aspirations—to
be a member of the National Academy, to be
thought of as a "fine artist," to associate with lead-
ing American Impressionists (as well as the politi-
cal and military elite)—constantly brought him
into conflict with others seeking similar goals.
Russell's self-effacing style, lack of social ambition,
and refusal to pass judgment on others' work
made him a difficult target.

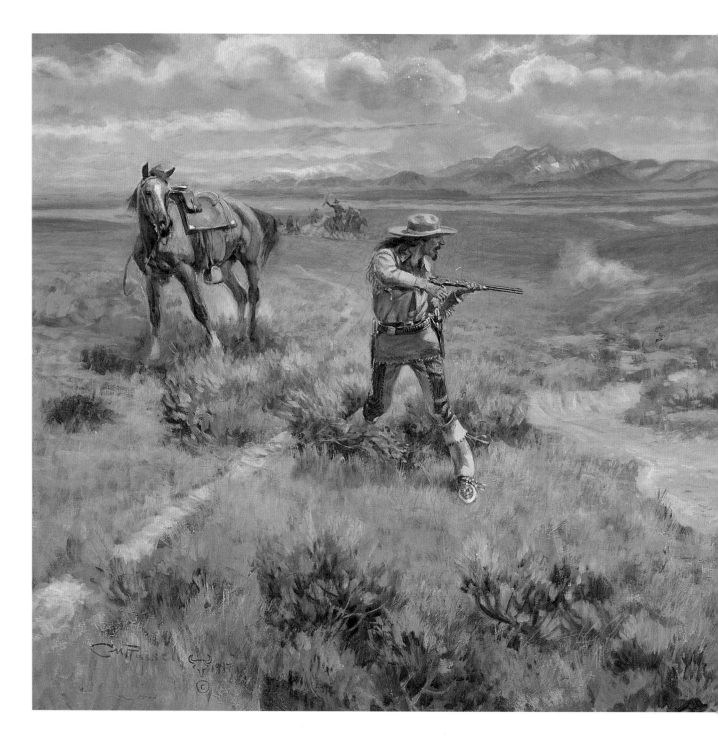

Since he had little to say about his methods, much of what we know of Russell's techniques must be gleaned from the comments of those who saw him at work. There is no doubt that he was meticulous, both in observation of the men, animals, and scenes which served as his raw material and in his depiction of them. His wife, Nancy, referred to the lengthy periods during which the artist would sit with a sketch pad plotting out the composition for a painting as "the big silence." Yet this same man could knock out a vital, dynamic sketch in just a few seconds time.

Waiting for a Chinook, for instance, was drawn on a scrap of cardboard, and other materials known to have been employed for existing works include buckskin, birch bark, rough wood, metal, glass, stoneware, and even dry fungus. The latter may seem particularly odd but fungus was a popular medium for Victorian "Sunday" painters.

In part these odd surfaces reflect the exigencies of the artist's early career when he often had no other material at hand. However, the fact that Russell continued to occasionally use them long after he could afford the best materials indicates both his humor and the casual manner in which Charlie viewed his art. These methods contrast quite a bit with Remington who, in general, is not known to have employed anything other than traditional materials.

Studio Artifacts and Models

Though he did not take to studio training, Russell was quick to observe and master techniques employed by others. While his early work was often crude and poorly composed, he advanced rapidly after returning from the first visits West to New York, where he had an opportunity to see how trained artists handled a subject.

His palette, previously dominated by browns and ochers, soon began to take on lighter and more varied color, while effects previously achieved only through detailed draftsmanship could now be accomplished through color alone. There was also improvement in composition. The disorganized mass of figures evident in such early works as *Breaking Camp* was replaced by a few carefully balanced ones, as seen in *Buffalo Bill's Duel with Yellowhand*.

Though Russell, like Remington, had a large collection of western artifacts to serve as props,

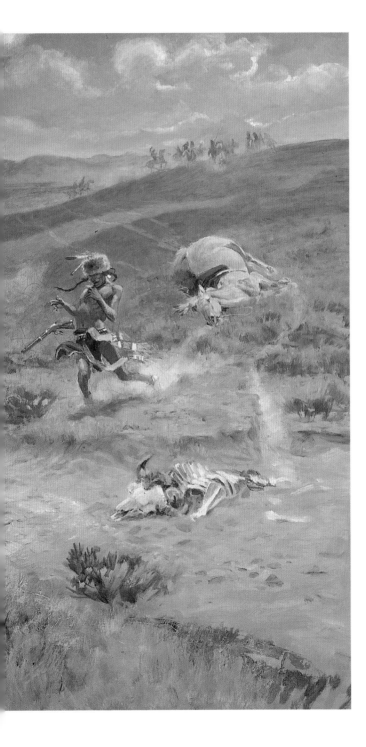

Following Page:

Indians Hunting Buffalo

Charles M. Russell

1894, oil on canvas. Sid Richardson Collection of Western Art, Fort Worth, Texas.

More impressionistic than most of the artist's work, this painting's focus is the white pony and the black bull with a background suggested more by color than line.

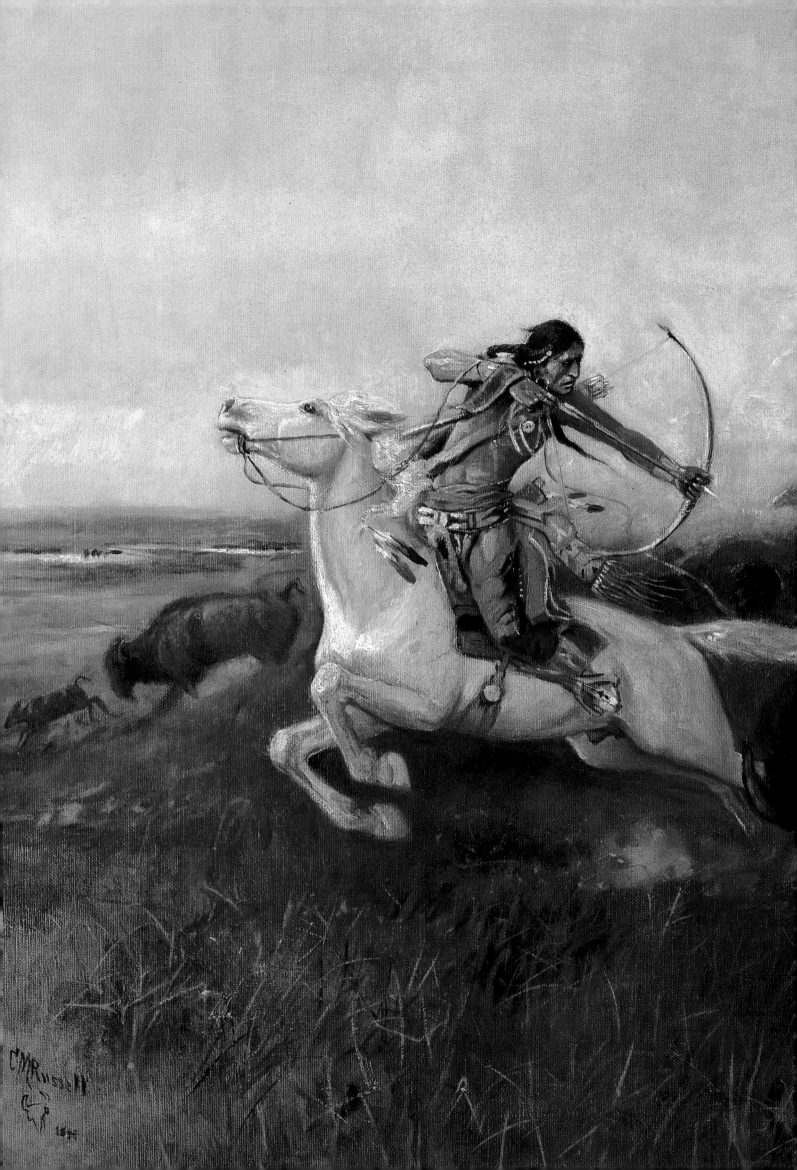

Charlie seldom had live models, though it was not for lack of trying. He got Nancy to pose in Indian garb for his well-known *Keeoma*, and he tried to induce others to serve as models, seldom successfully:

> I couldn't get a puncher to pose for me ... They didn't like it. Why the devil should I sit there like a fool?, they'd ask me. As for Injuns, they'd jes' get up and walk away. The most I could do was get them to sit awhile.

He would even resort to utilizing his own body, twisting himself into various positions in order to observe the appearance of the musculature under tension.

But Russell could also sketch rapidly and accurately, and his subjects were quick to point out any errors. He once remarked that "I used to sketch the other boys on the range . . . [and] those fellers are good critics as to detail, now let me tell y'u. Why, they'll see anything that's left outa the picture or if the colors don't happen to be right." Perhaps the highest compliment to the artist's ability was paid by an old wrangler who remarked that "[if] he painted a naked cowboy swimming across a river, you'd know it was a cow puncher!"

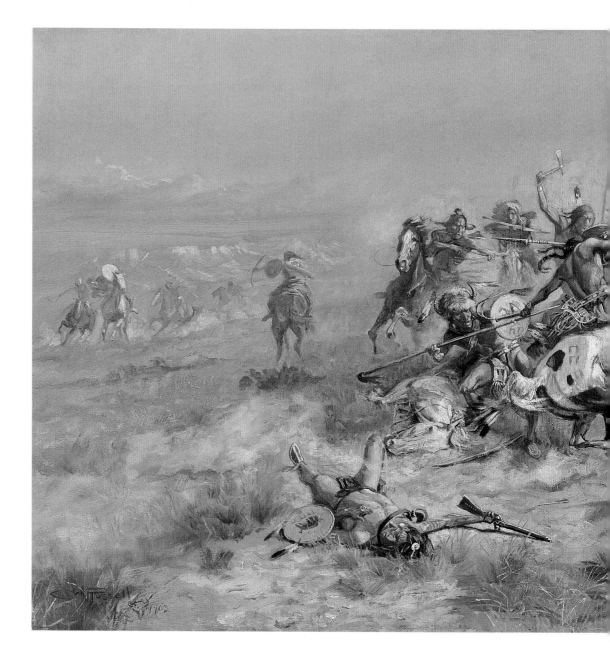

Counting Coup

CHARLES M. RUSSELL

1902, oil on canvas.

Sid Richardson

Collection of Western

Art, Fort Worth, Texas.

This painting is based on a tale of a skirmish between Sioux and Blood Indians as told to Russell by a Blood chieftain and is an example of the artist's use of traditional stories for pictorial themes.

Horse Operas

While all of the western scene interested him, Russell's favorite subject was the horse, particularly the western bronco or "cayuse," the horse he rode and understood best (and the one that, on occasion, would even pose for awhile). He was also fascinated by the Indian bison hunt or "surround" in which a group of braves mounted on horseback would swoop down on a herd, cutting out and killing the animals they wanted. So often did Russell do variations of this scene that the fifty or so known versions have been given individual numbers, such as *Buffalo Hunt No. 15*.

Charlie's depictions of Native Americans, including a group of portraits of tribal types with which he was familiar, are invariably sensitive, even where the individuals pictured are engaged in acts of violence.

Much the same may be said for his treatment of the cowboy, a figure he knew intimately and whose life he had shared. However, he did not hesitate to poke fun at his trail companions, and many of Russell's so-called barroom watercolors and sketches dwell on the foibles of these hard-riding and hard-drinking innocents, including a number of scatological sketches intended for private saloon rooms and men's clubs.

Critiquing the Critics

In his pictorial humor, Charlie differs greatly from Frederic Remington, who shows little fun in his work and who, unlike the earthy Montanan, seems to have been particularly uncomfortable with anything pertaining to sex. The distinction may be one of both class and locality. Russell matured on the western plains where there were few women, all of whom, prostitutes or school teachers, were held in awe and great respect. (Charlie once upbraided a friend who was running down a cowboy they knew for marrying a former bordello girl by declaring that "the worst woman alive, in my opinion, is as good or better than the best man I know.") Remington, on the contrary, reflected the bourgeois Victorian view that there were only two types of women, the ones you married and the ones (for him, Spanish-American prostitutes) you slept with on the sly.

Also unlike Remington, who aspired to inclusion among modern artists, Russell had little good to say about the Impressionists or Cubists, declaring after a London visit:

> I can't savy that stuff . . . It may be art but it's over my head. Now I may paint a bum hoss, but people who know what a hoss looks like, will know I tried to paint a hoss at least. Most people can't savy this dreamy stuff.

He was equally disdainful of the then current practice of going abroad to study under European artists, once remarking that he didn't "see how a Dutchman or a Frenchman could teach me to paint

the things in my own country." Of course, he was equally disinterested in American art training.

Ultimately, Russell was his own man in his own time. His valued critics were those who had known the life he led; the professional art pundits he likened to fleas: "They live off the dog, but they don't do him any good."

"It's All in Feeling It"

When in the winter of 1908 Frederic Remington consigned to the flames of a backyard bonfire his *Bringing Home the New Cook*, *Drifting Before the Storm, The Unknown Explorers*, and thirteen other original works, it marked his final separation from the world of illustration. Like Russell he had started out as an illustrator, but he wanted something more. Buoyed by glowing reviews for his most recent one-man exhibition, he now felt confident enough to turn his back on his former field, and, as he had done in altering his life story, he attempted to expunge the art he no longer wished to have associated with his name.

It had not always been so. He had long been delighted with the fame,

money, social contacts, and opportunity to travel that working as an illustrator brought him. And he was very good at what he did. He traveled the West armed with a camera, sketchbook, and diary in which he carefully noted details such as colors (". . . shadows of horses should be a cool carmine & blue . . . Arizona, the earth is of a blue red color . . . any water settled on the plains is yellow ochre and gamboge") so that when in the studio he could accurately reproduce the scene he had witnessed. But this "reproduction" was never a simple copy. The artist's role is to transform reality, and as Remington remarked, "the interesting never occurs in nature as a whole, but in pieces. It's more what I leave out than what I add."

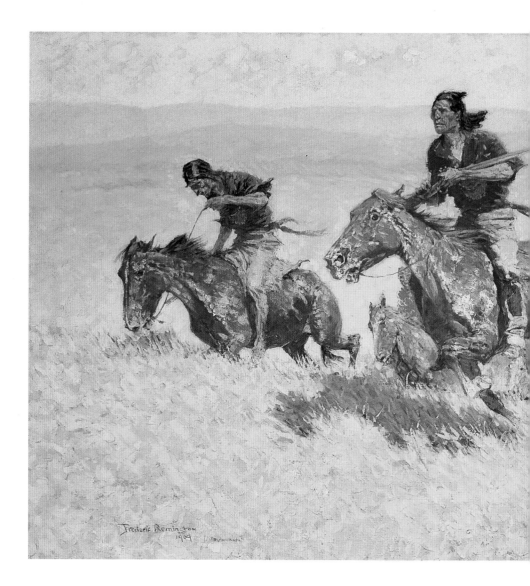

The Buffalo Runners, Big Horn Basin

FREDERIC REMINGTON

1909, oil on canvas.

Sid Richardson Collection of

Western Art, Fort Worth, Texas.

One of the Remington's last works and considered by many to be the artist's finest impressionistic painting, this symphony of color and movement captures the vigorous drama of the buffalo chase.

In order to accommodate himself to the technical problems of illustration which, in his early career was almost entirely in black and white, he added to his skill in color wash drawings the ability to do pen-and-ink sketches (easier for the engravers to duplicate), as well as black-and-white or monochromatic oils.

As soon as he could afford them, Remington employed models to sit for him, including horses, but he usually did not labor over a work for weeks or months. Once he had visualized a composition he worked at remarkable speed. He once noted that when "I kind of get my idea of what I am going to do, then the rest of it is nothing. I've made the best things I ever did in two hours. It is all in feeling it."

Riding Herd in the Rain

FREDERIC REMINGTON

n.d., wash drawing. Buffalo Bill Historical Center, Cody, Wyoming.
This monochromatic work is characteristic of hundreds that Remington produced as illustrations for articles and stories, both his own and those of other writers.

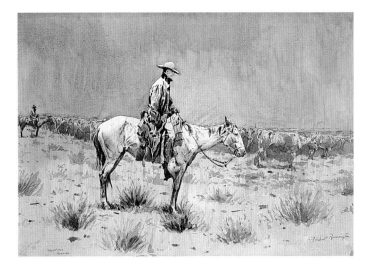

Horses in Motion

One of Remington's favorite subjects was, naturally, the horse (he hoped to have the epithet "He knew the Horse" engraved on his tombstone), and in depicting it he achieved a major artistic breakthrough. Prior to his arrival on the artistic scene the classic way to portray equine motion was the "hobby horse" position, with both front legs extended forward and the rear ones stretched backward in the same manner.

Remington, on the basis of his own observation and also quite possibly through having seen some of the photographs of running horses taken by the English photographer Eadweard Muybridge, drew the animal in motion physiologically correct, with the forelegs folded at the gallop and either fore or hind legs extended at the moment the other set is vertical—i.e., never in the hobby-horse position.

This innovation, proven in Muybridge's work to be correct, was introduced by Remington as early as 1886. It gave a heightened sense of reality to the artist's horse paintings and, since it made their prior work look somewhat ridiculous, it was the first thing that the Academicians held against him.

American Impressionism

Like Russell, Frederic Remington had a unique vision; he too was a driven man. In 1888 a friend remarked that "Fred is the same as ever—very ambitious and confident. He is bound to kick and fight his way to the front, and will do it without going to Paris or Rome." But while he shared Charlie's disdain for foreign study and foreign artists, Remington was open to new techniques.

The Snow Trail

FREDERIC REMINGTON

1908, oil on canvas. Remington Art Museum, Ogdensburg, New York.
In this dramatic piece the colorfully garbed Indian trackers are set against a shimmering snow ground. Color and composition are of the essence; the picture's "story" is far less important. Remington at this point is no longer merely an illustrator.

He was particularly impressed by the works of those painters who would, in later years, be referred to as the American Impressionists.

He loved their use of color and light, the fluidity of their work, and the direct emotional impact it had on the viewer. Yet he feared that he could not work in that manner. Years of black-and-white illustration had dulled his sense of hue. He could not yet paint with the Monet palette, but gradually he felt his way in that direction, beginning with pastels—not a new medium for him but one that seemed to lend itself to both the use of color and a looser style.

Though Frederic was often pleased by his ventures into color, critics sometimes were not. Following a Boston exhibition in 1897, a pundit declared that his "unfeeling realism and his poverty of color are formidable handicaps." But what is one against millions? Only a year later the U.S.

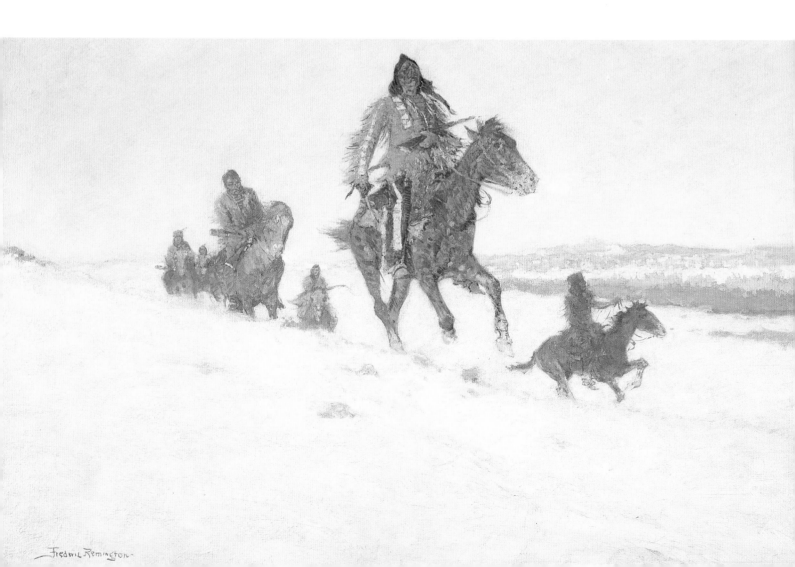

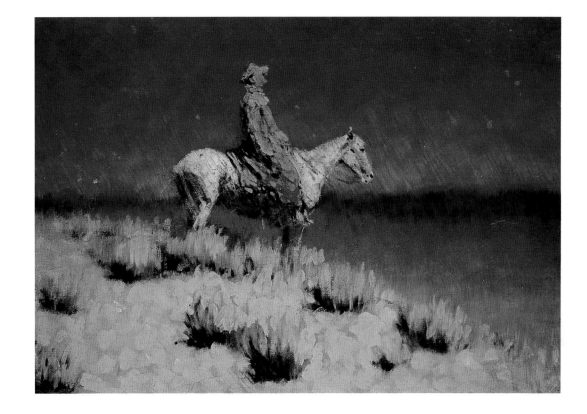

The Night Herder

FREDERIC REMINGTON

n.d., oil on board.

Buffalo Bill Historical

Center, Cody, Wyoming.

More important for its
use of color than the
subject matter, this early
Remington night scene
reflects the painter's
movement from literal
illustration toward an
impressionistic approach.

Postal Department selected two of Remington's drawings, *Protecting a Wagon Train* and *The Gold Bug*, to illustrate stamps in the series issued to commemorate the 1898 Omaha Exposition. The final printing resulted in 3,500,000 miniature Remingtons.

The Dark of Night

Still, the artist sought the Impressionist palette, but he found that everything he did after years of monochromatic art got darker and darker. His big breakthrough occurred in 1899 when he viewed an exhibition of nocturnal paintings by the California artist Charles Rollo Peters. If he could not yet paint the colors of the day, he decided, he would paint those of the night—the dark blues and the silver sheen of moonlight.

He had, in fact, become fascinated with light, describing painting as "an expression of light" and asserting that a canvas should "glow and quiver until it seems to exude the palpitating quality which light holds."

By 1903 Remington was preoccupied with paint-

ing night scenes such as *The Night Herder* and *Fired On*. When exhibited, these attracted favorable critical attention. He was now an intimate of the so-called Ten—the leading American Impressionists—and to his entry in the prestigious *American Art Annual* was added the notation "painter." Previously he had been listed just as an "illustrator" and "sculptor."

With his technique freed up and his color sense sharpened, the artist then moved into daylight scenes, such as *The Fight for the Water Hole*. The impressionistic rendering, with its blurring of outlines and emphasis on light and color replacing detailed draftsmanship, delighted most critics and did not appear to disturb his vast lay audience. By now, they too were ready for the new art.

Despite his changing technique, though, Remington rarely changed his subject matter; the West and its inhabitants—cowboys, mountain men, and, particularly, the cavalry and its constant antagonist the Indian—remained for him the subject he was most devoted to as an artist.

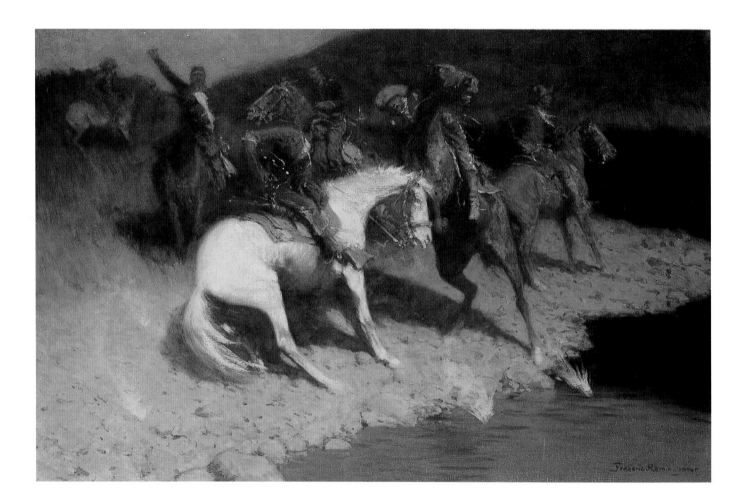

Fired On

FREDERIC REMINGTON

1907, oil on canvas. Art Resource/National Museum of American Art, Washington, D.C.

By 1907 Remington had perfected his night scenes, remarkably subtle
explorations of dark and light that, as here, suggest more than they reveal.

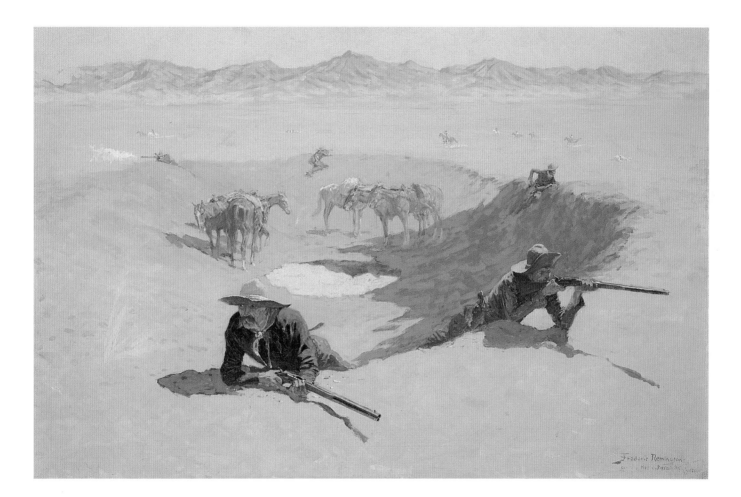

The Fight for the Waterhole

FREDERIC REMINGTON

1901, oil on canvas. Museum of Fine Arts, Houston, Texas.

Both the freer use of color and the reduction of the number of figures in the
composition reflect Remington's growing identification with the Impressionist art movement.

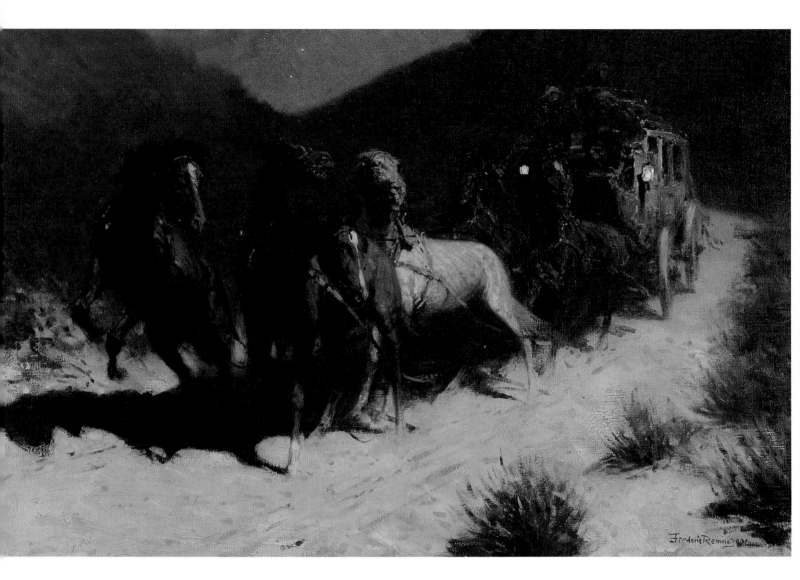

A Taint on the Wind

FREDERIC REMINGTON

1906, oil on canvas. Sid Richardson Collection of Western Art, Fort Worth, Texas.

One of the artist's most luminous nocturnals, this painting
was shown to great acclaim at the Knoedler Gallery
exhibit of 1906. As with a significant number of the artist's
later works, danger is hinted at rather than directly shown.

The Last March

FREDERIC REMINGTON

1906, oil on canvas. Remington Art
Museum, Ogdensburg, New York.
This is a masterful example of the
artist's use of suggestion in his
late works—the lost cavalry mount
dogged by wolves hints at a battle,
a fallen rider, and the inevitable
consequences of starvation and cold.

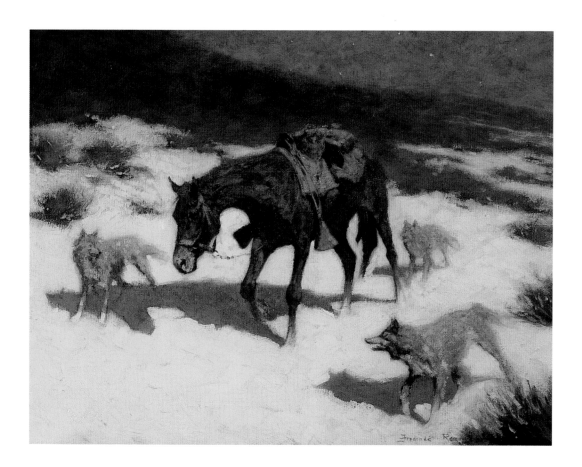

Lewis and Clark Meeting the Flathead Indians at Ross' Hole

CHARLES M. RUSSELL

1912, oil mural on canvas. Montana Historical Society, Helena, Montana. Regarded by many as Russell's most important work, this monumental painting (12 by 25 ft. [3.66 x 7.62 m]) was created for the chambers of the Montana House of Representatives.

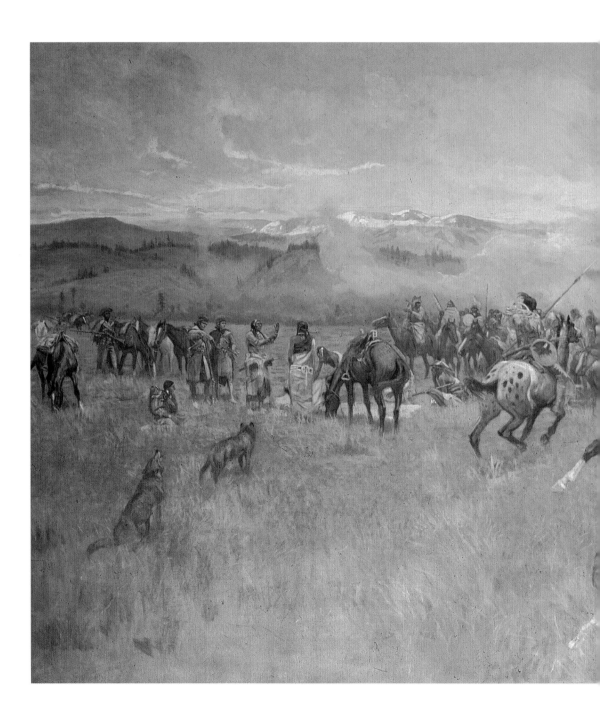

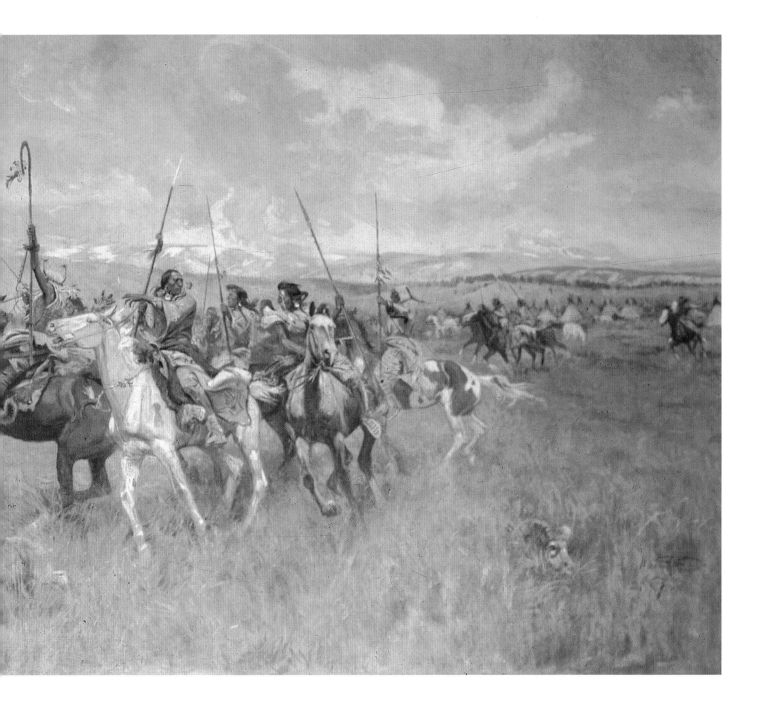

Lewis and Clark on the Lower Columbia

CHARLES M. RUSSELL

1905, watercolor on paper.

Amon Carter Museum, Fort Worth, Texas.

One of the few historical paintings done by Russell, this
work depicts the explorers Meriwether Lewis and William
Clark at the time they reached the Pacific in November of 1805.

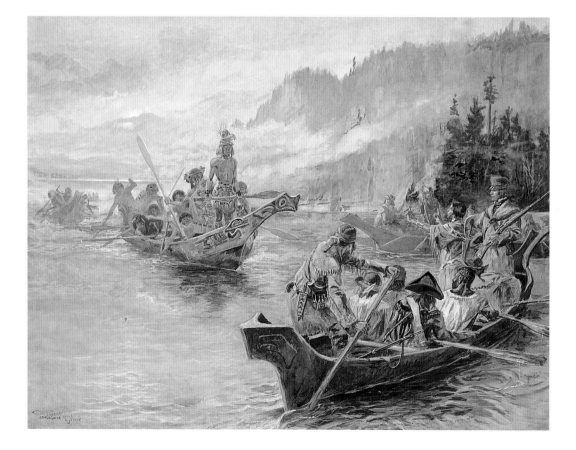

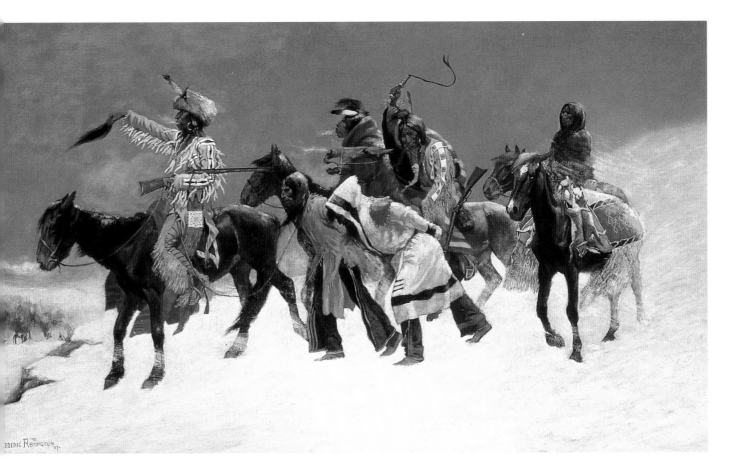

Return of the Blackfoot War Party

FREDERIC REMINGTON

1887, oil on canvas. The Anschutz Collection, Denver, Colorado.
This grim rendition of a Native American version
of the Roman Triumph was repainted several
times, with the artist eventually reducing the
number of figures and altering their relationships.

FOLLOWING PAGE:

The Jerkline

CHARLES M. RUSSELL

1912, oil on canvas. C. M. Russell Museum, Great Falls, Montana.
Russell knew personally some of the freighters with
their long lines of horses and mules who, until the com-
ing of railroads, carried most of the western produce.

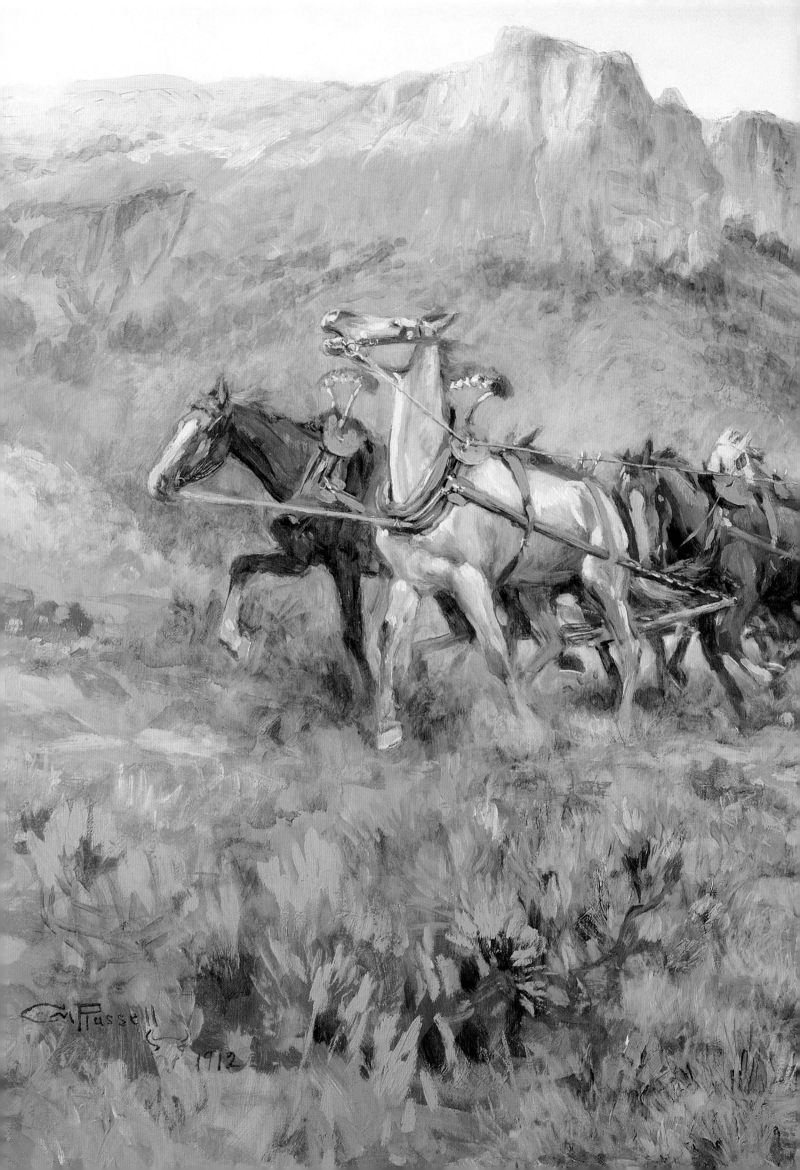

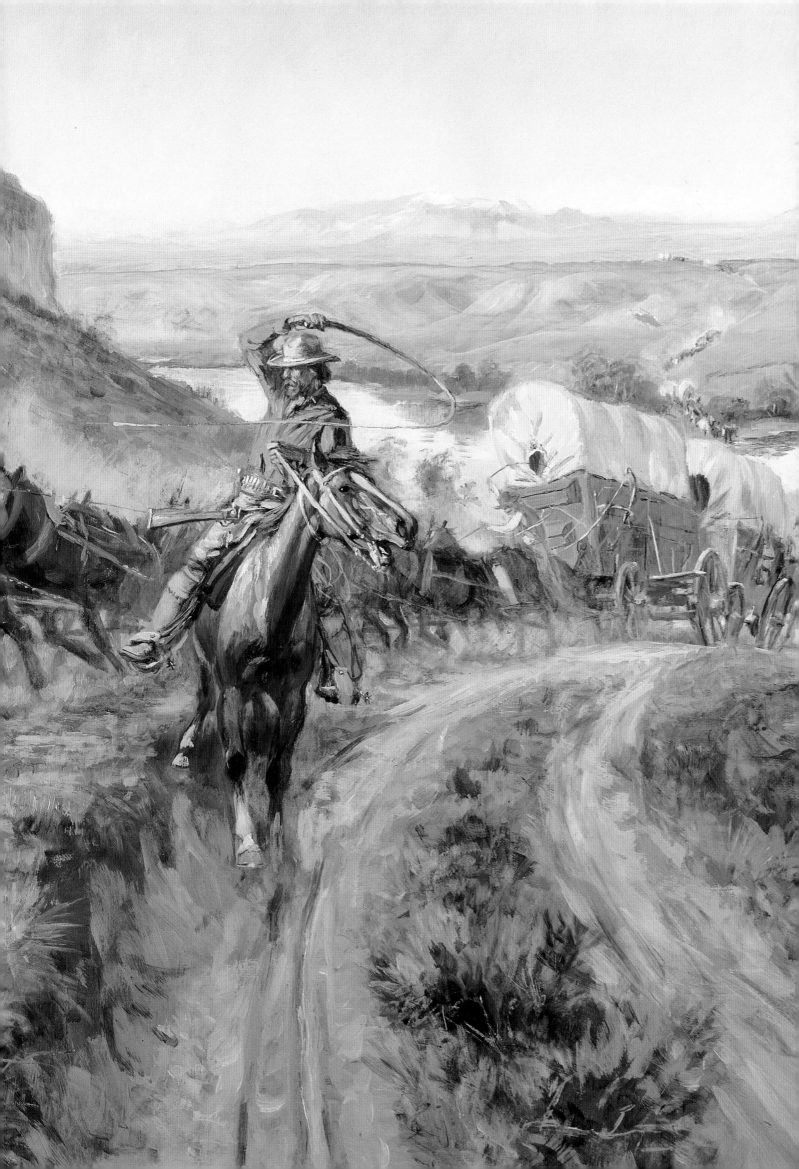

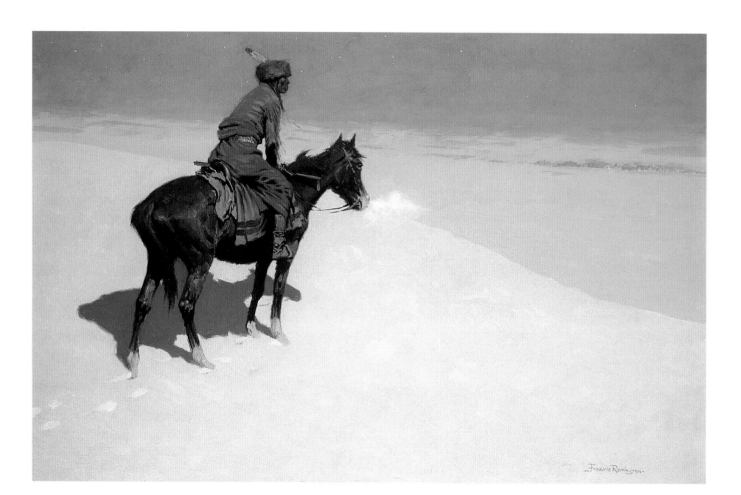

The Scout: Friends or Foes

FREDERIC REMINGTON

c. 1900-1905, oil on canvas. Sterling and Francine Clark Art Institute, Williamstown, Massachusetts.

Through a single figure peering into the snow-filled distance
the artist manages to convey both the great loneliness of the
American plains and the constant perils that they concealed.

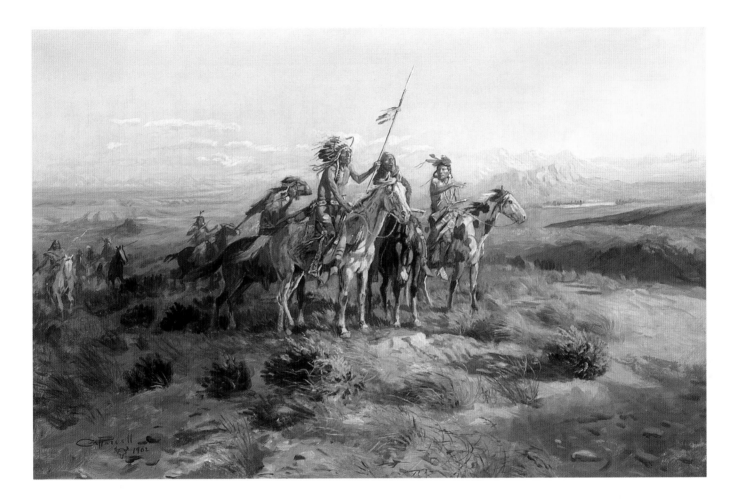

The Scouts

CHARLES M. RUSSELL

1902, oil on canvas. The Anschutz Collection, Denver, Colorado.

Having lived for a time with the Blood Indians, Russell was knowledgeable
in their ways and could accurately portray them, as in this example
depicting a scouting party seeking game or enemies in the high country.

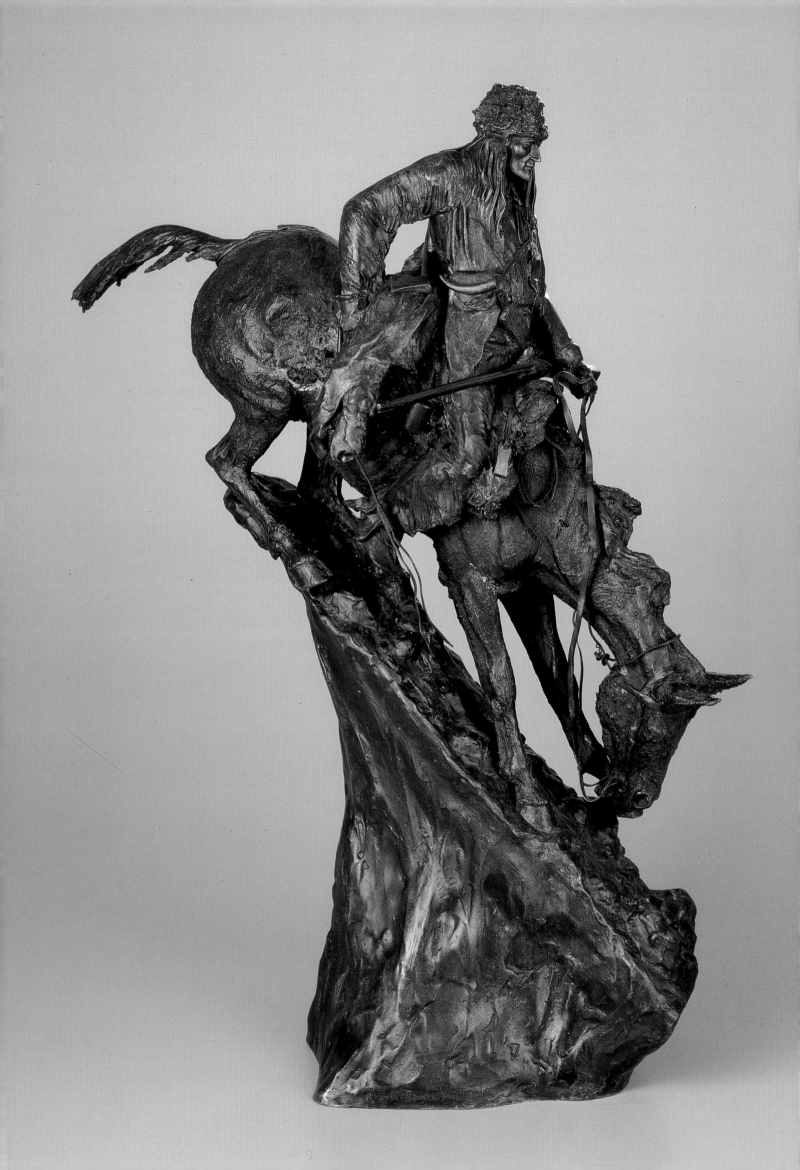

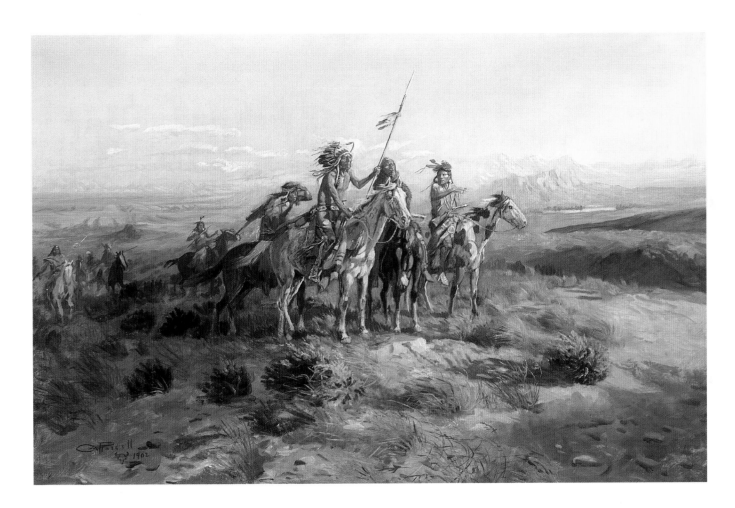

The Scouts

CHARLES M. RUSSELL

1902, oil on canvas. The Anschutz Collection, Denver, Colorado.

Having lived for a time with the Blood Indians, Russell was knowledgeable
in their ways and could accurately portray them, as in this example
depicting a scouting party seeking game or enemies in the high country.

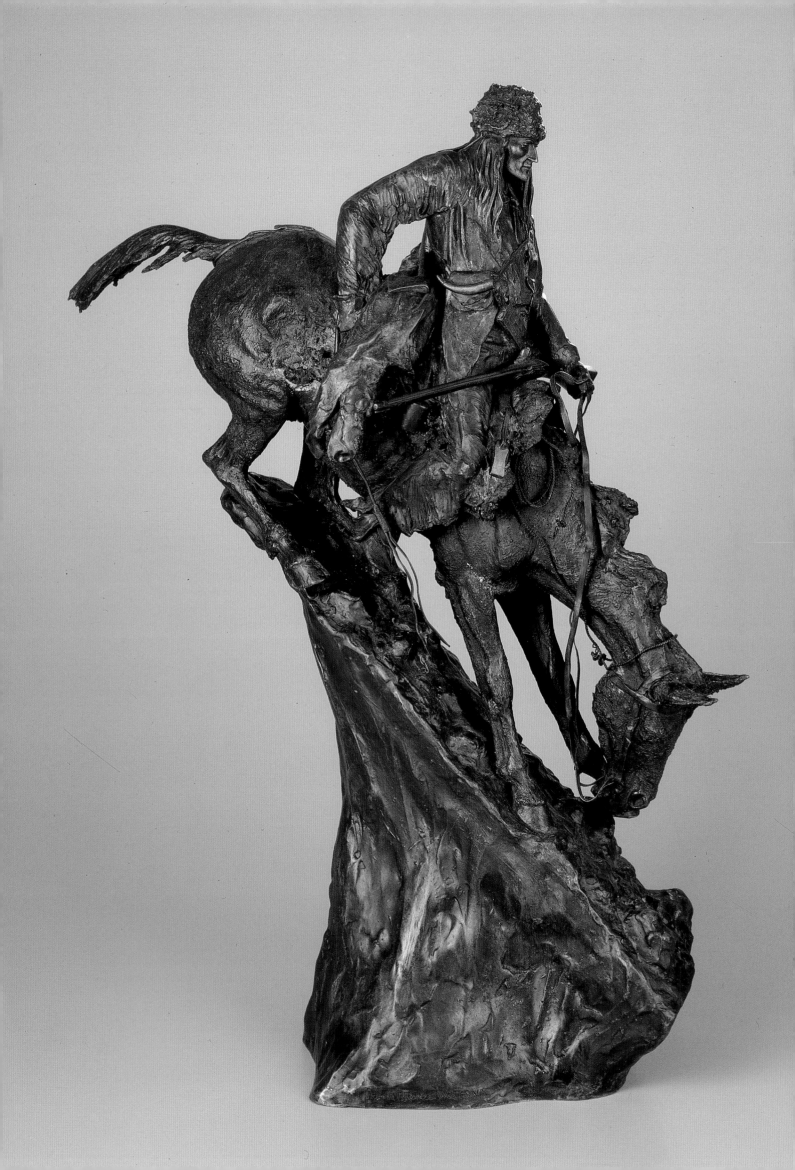

The Bronzes

Unlikely as their success as artists might have been, it was even less likely that Frederic Remington and Charles Russell would achieve fame as sculptors. Not only did neither of them have any formal training in the field, but their penchant for realism directly contradicted the most dearly held tenets of the academic art community. At a time when classical sculptors were filling museums and public spaces with Civil War generals clad in Roman tunics and swooning maidens clutching doves, Remington and Russell were concerned about details of authenticity: Was the bridle correct for a Sioux war pony? Did a cavalry trooper carry a Sharps rifle in 1878?

Such concern for historical accuracy was not only of no interest to the academicians, it infuriated them. Art, for the established Victorian sculptors, was incompatible with reality. Only by transforming life into allegory, they believed, could one make an artistic statement. This gulf in perception and technique stood always between them and the two great western sculptors; yet it was, perhaps, inevitable given the fact that neither Remington nor Russell had ever been exposed to the academic credo regarding sculpture. In fact, both came to the field in the most casual manner.

The Mountain Man

FREDERIC REMINGTON

1903, bronze. Buffalo Bill Historical Center, Cody, Wyoming.

Though they were long gone by Remington's day, the fur trappers or "Mountain Men" who frequented the western ranges during the 1830s and '40s had always fascinated the artist.

Clay and Wax Models

Charlie Russell's involvement in sculpture was of greater duration. He had started modeling clay as a child; his first remembered work was an eagle which he had copied from an engraving in a book, dutifully inscribing his example "Copyright Reserved," just like the original model.

By the time he was eight, Russell was borrowing wax from an older sister (she used it to fashion wax flowers, a common Victorian ladies' craft) with which to create small models of domestic and wild animals. That the youthful sculptor had some talent in this field was confirmed when at age twelve he entered a clay bas-relief of a knight on horseback in competition at the St. Louis County Fair. His creation took first prize, as did another plaque, of a mounted cowboy, exhibited the following year.

Once he went West, though, the artist's opportunities to pursue the plastic art were severely limited. A man named William Korrel, who had a ranch not far from the Waite & Miller place where Charlie was herding sheep in 1880, described how the artist carried a ball of beeswax from which he would model figures, even keeping the nail on his right little finger unusually long to serve as a tool in incising details.

Moreover, Korrel confirms that during this period Russell built a small pottery kiln:

While he was working for Miller and Waite, he discovered along the bottom lands of upper Waite Creek, some clay that he could burn. From workmen at his father's plant in St. Louis, he had learned something about clays and the process required to

fire them to the desired hardness without ruining the object in hand. He at once erected a rude kiln, and spent most of the time in which he was supposed to be herding sheep in modeling and firing the likenesses of dogs, hogs, horses, cattle, bears and other creatures and characters.

Unfortunately, none of these early figures appears to have survived, and once he became a night herder Charlie had neither the time nor the facilities to pursue his sculpture.

Nevertheless, he continued, whenever possible, to model, employing the bits of beeswax or clay he always had tucked away in his pockets. This single-mindedness could be disconcerting to his trail companions. Bill Rance, who roomed with Russell one winter in Great Falls, once described the artist's nocturnal activities:

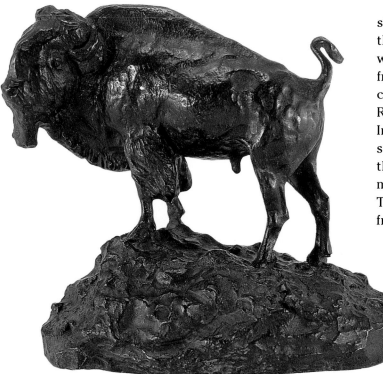

Standing Buffalo

CHARLES M. RUSSELL

1901, bronze. C. M. Russell Museum, Great Falls, Montana.
More than any other animal, Russell saw the bison as the symbol of the old West and viewed its disappearance as the hallmark of the new, and to him unappealing, era of farms, mines, and towns.

Charlie . . . modeled so much it sometimes got on my nerves. At night, Charlie'd lay in bed with his hands hangin' down close to the floor. Pretty soon he'd bring up some little animal he'd made. When I'd get tired I'd say "Aw, hell, Russ, forget that stuff. Let's get some sleep."

Even when he was finally established as an artist in his own studio, Russell at first used modeling as an aid to painting rather than viewing it as an independent art. Most of his watercolors and oils portrayed men and animals in the throes of violent exertion—running, riding, or fighting. It was not possible for a model, man or beast, to hold such poses, so Russell would sculpt in wax or clay miniature figures in the desired pose. These would then be arranged in a tableau on a small stage in the studio, and, using this as a compositional guide, the artist would paint or draw from it.

This unusual technique, though born of necessity, reflected Charlie's continued interest in a field that had been his first love. However, he never worked in wood or stone and Montana was far from the foundries where his creations might be cast into bronze. As a result, it was years before Russell's sculpture came to general public notice. In the interim he created hundreds of finely sculpted human and animal figures in clay or wax, the latter often colored. These were sometimes made for special occasions such as birthdays, Thanksgiving, and Christmas, or as gifts for friends. Of all, perhaps fifty survive, some later cast for commercial purposes as book ends, ashtrays, and the like.

First Russell Bronzes

It was during the 1903–04 trip to New York City that Russell had his first model cast in bronze. Uncomfortable in the big city and left alone in his room while his wife visited publishers seeking work for him, Charlie modeled the figure of a cowboy on the spree, called *Smoking Up,* which, perhaps, reflected both his nostalgia for his once carefree life on the plains and his present sense of estrangement in the great metropolis.

Manhattan's Co-Operative Art Society learned of the work and purchased the right to have five

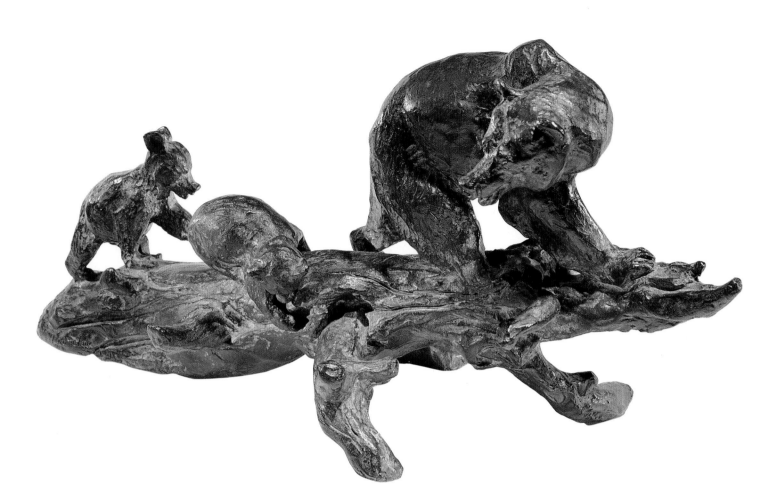

Mountain Mother

CHARLES M. RUSSELL

1916, bronze. Amon Carter Museum, Fort Worth, Texas.
Russell's profound knowledge of and empathy
for western American wildlife is reflected in
this work depicting the maternal instincts of an
animal generally feared by settlers and cattlemen.

bronze castings made, one of which was presented
to President Theodore Roosevelt, who already
owned bronzes by Remington. Cast at the presti-
gious Roman Bronze Works, the same establish-
ment that produced Remington's bronzes,
Smoking Up met with immediate public favor.

When the artist returned to New York in 1905 he
had three more models—*Counting Coup, Scalp
Dance,* and *The Buffalo Hunt*—cast in bronze. Of
far more complex composition than *Smoking Up,*
these works displayed the artist's ability to ma-
nipulate his medium to capture the most explosive
and dramatic interactions between man and beast
while at the same time retaining an exacting fi-
delity to detail. Offered for sale at Tiffany's in the
same year, these pieces commanded prices of
$450, $180, and $450 respectively; hardly a fortune
but very nice for a night wrangler.

Russell went on to produce a large number of
bronzes, fifty-three of which were cast during his
lifetime. The only complete set of these, known as
the "Original Russell Bronzes," is at the Amon
Carter Museum of Western Art in Fort Worth,
Texas. A substantial number of other works were

cast from Russell models after the artist's death.

With the exception of examples such as *Will
Rogers,* a tribute to the sculptor's close friend, the
sculpted works fall into three general categories:
animals, Native Americans, and cowboys. Russell
knew intimately not only the appearance but the
behavior of these favored subjects, and his fond-
ness for them led him to portray them in the most
sympathetic manner.

No other American sculptor has equaled his por-
trayal of the bear, as depicted in *Mountain Mother,*
or the bison *(Standing Buffalo),* while his *Watcher
of the Plains* captures the intense drama of the
Indian struggle for survival against nature, tribal
enemies, and the ever encroaching white tide.

"Frederic, You're a Sculptor"

Charles Russell showed a lifelong interest in the sculptural form but Frederic Remington came to it late, and almost by accident. Already well established as an artist and illustrator, in 1895 while Remington was painting in his studio an observer, the playwright Augustus Thomas, noted that in shifting the figures of a work around to achieve the desired relationships the artist was actually treating them in a plastic sense. Thomas excitedly proclaimed:

> Frederic, you're not a draftsman; you're a sculptor. You don't mentally see your figures on [just] one side of them. You saw all around that fellow, and could have put him anywhere you wanted him. They call that the sculptor's degree of vision.

Remington was familiar with academic sculpture and had always thought highly of the horse bronzes produced by Russian and Polish sculptors. With such encouragement, though, he wasted little time. Less than a week later when another friend, the sculptor Frederic W. Ruckstull, came to visit, Remington posed the question: "Ruck, do you think I could model?" The affirmative response was quick in coming. "Certainly . . . you see in your mind anything you want to draw. You will be able to draw as clearly with wax as you do on paper."

Assisted by Ruckstull, who furnished him with tools, a modeling stand, and wax as well as some basic advice, Remington set to work choosing for his first piece what was to become known as *The Bronco Buster*, a heroic representation of a cowboy atop a rearing stallion. The vertical orientation of the work presented serious technical problems, however. The weight of the bronze, resting only on the horse's two hind legs, was apparently too great. The traditional remedy was the "Grecian post"—a bronze shaft, often disguised as a tree trunk, which supported the horse's body.

Remington was unwilling to make this compromise. After watching Ruckstull, who was at the same time creating an equestrian statue, he altered his work, enlarging the supporting armature and creating a delicate balance, the success of which would not be known until the casting was attempted.

For this process he chose New York's Henry-Bonnard foundry, which employed the most up-to-date sand-casting technique available at the time. The work took months, encountering difficulties due to Remington's radical design, but it was at last completed. The soon-to-be renowned piece was copyrighted on October 15, 1895.

The Bronco Buster

The Bronco Buster burst like a thunderclap upon the New York art scene. Few, particularly his detractors in the Academy, were aware that Remington had turned his hand to sculpture. Responses were predictable. The press and public loved the work. *The New York Times* declared that *The Bronco Buster* "presents Mr. Remington in a new and unexpected light, opening up new possibilities in a field wherein he will be quite alone . . ."

However, the established sculptors and their supporters damned him with faint praise. One critic noted that "this highly literal accuracy has little to be said for it to those of the public who have pedestaled the element of imagination in art," while another made the point more directly, declaring that "Mr. Remington is not ever likely to conceive a theme sculpturally."

Frederic, though sensitive to the criticism, was much more interested in the creative and financial possibilities of his new medium. Concerned as ever with posterity, he was delighted that he could now create "something a burglar wouldn't have [presumably due to its weight], moths eat or time blacken." Then, of course, there was the money. Unlike paintings, bronzes could be produced in multiple copies. There they would sit in Tiffany's window, at $250 apiece, waiting to be sold while he went about his other artistic business. Within three years forty-five of the castings were sold, and in 1898 when the famed Rough Riders were mustered out of service after the Spanish American War, a copy of *The Bronco Buster* was presented to their leader, Colonel Theodore Roosevelt.

The Rattlesnake

FREDERIC REMINGTON

1905, bronze. Buffalo Bill Historical Center, Cody, Wyoming.
Though regarded by some critics as the sculptor's
most fluid rendition of a bucking horse, this
piece was not popular with customers
due to a general dislike for snakes,
especially venomous ones.

Enduring in Bronze

In July of 1896 Remington copyrighted his second bronze, *The Wounded Bunkie*. A complex multifigure composition, it not only ably illustrated the sculptor's remarkable technical skills but its subject matter (a cavalryman supporting a wounded companion) once more reflected Frederic's continuing interest in one of his favorite topics, the military. Costly for the period at $500, *The Wounded Bunkie* was produced in a limited edition of only twenty, fourteen of which sold.

Though he was involved over the next few years in a variety of pursuits—painting, writing, and traveling—Remington continued to sculpt. In 1898 he produced *The Wicked Pony*, a dramatic scene of equine disaster which, while brilliantly executed, did not find favor with the public due to its tragic subject matter—a marketing problem hardly improved by Remington's declaration that he had

witnessed the very scene and, "yes," the cowboy had been killed!

The same year saw completion of *The Triumph* or *The Scalp*, a study of an Indian on horseback brandishing a scalp. As in other works, such as *The Savage*, Remington here emphasized the violent nature of Native Americans. Yet there is an impassioned energy in the piece that cannot be denied.

In 1898 a fire destroyed the Henry-Bonnard shop, and from 1901 Remington had his sculptures cast at the Roman Bronze Works in Manhattan, which utilized the newly adopted lost-wax process—a method that offered the artist more freedom in the sculpting. He established a close relationship with the firm's founder, Ricardo Bertelli, and involved himself in all the details of the intricate casting process.

Always conscious of his market, Remington

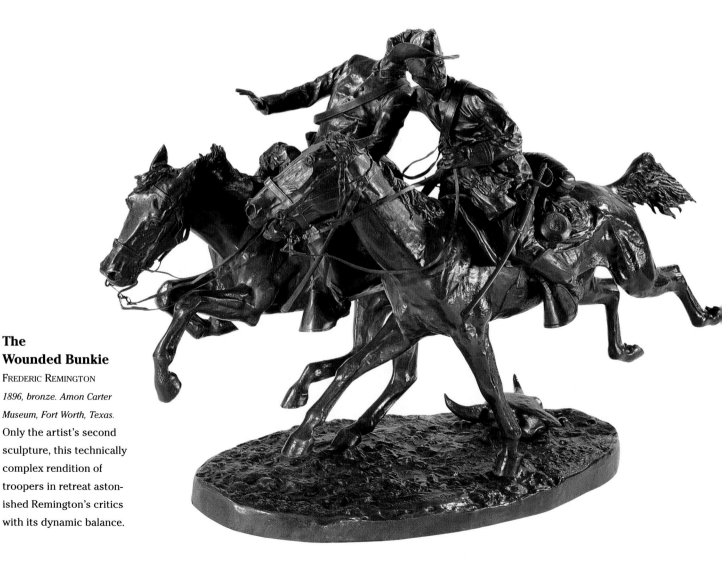

The Wounded Bunkie

FREDERIC REMINGTON

1896, bronze. Amon Carter Museum, Fort Worth, Texas. Only the artist's second sculpture, this technically complex rendition of troopers in retreat astonished Remington's critics with its dynamic balance.

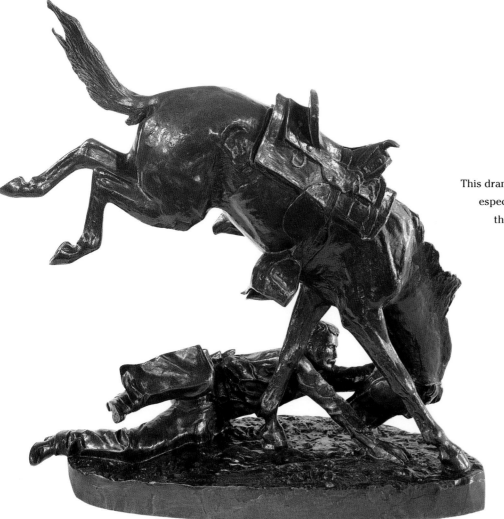

The Wicked Pony
FREDERIC REMINGTON
1898, bronze. Amon Carter Museum,
Fort Worth, Texas.
This dramatic sculpture never sold well,
especially after the sculptor assured
the media and anyone who asked
that he had witnessed the
scene depicted and that
"Yes, the cowboy
was killed."

balanced his production, creating representations of Native Americans like *The Savage* and *The Cheyenne* alongside heroic portrayals of frontiersmen, such as *The Mountain Man* and *Jim Bridger,* and sculpted paeans to cowboys, like those depicted in his ever popular *Coming Through the Rye*; in addition to depictions of his first love, the cavalry, as personified in *The Old Dragoons of 1850* and *The Sergeant*.

Despite his other commitments, the artist turned out one or more works each year to rising public acclaim. A large plaster cast of *Coming Through the Rye* was exhibited at the 1904 Louisiana Purchase Exposition in St. Louis, and over forty examples of the piece were sold through Tiffany's at a price of $2,000 each.

In the same year, during an exclusive exhibition of Remington bronzes at the Knoedler Gallery, two pieces, *The Mountain Man* and *Coming Through the Rye*, were purchased by the Corcoran Gallery of Art in Washington, D.C., marking the first time that a museum had acquired the artist's statuettes.

Yet what Remington longed for was to see one of his works placed in a public site, the sort of com-mission that went regularly to the academic sculptors. This hope was at last realized in 1908 when his monumental bronze *The Cowboy* (some 16 feet high and eighteen feet long [4.88 x 5.49 meters]) was unveiled in Philadelphia's Fairmont Park, a home too to various works by members of the hallowed Academy.

In all, Frederic Remington produced twenty-two bronzes. The last of these, *The Stampede*, was completed in clay shortly before the attack of appendicitis which resulted in his death. It was cast at his widow's direction and copyrighted April 13, 1901.

The dramas Remington created on canvas as well as in bronze were almost too lifelike for some of his audience. He once remarked after some admirers had expressed concern for the fate of the protagonists in a certain work that "they take my pictures for veritable happenings & speculate on what will happen next to the puppets so arduous are boys' imaginations." Not just boys; for all Americans Frederic Remington's work—along with that of his peer Charles Russell—remain the definitive expressions of the Old West.

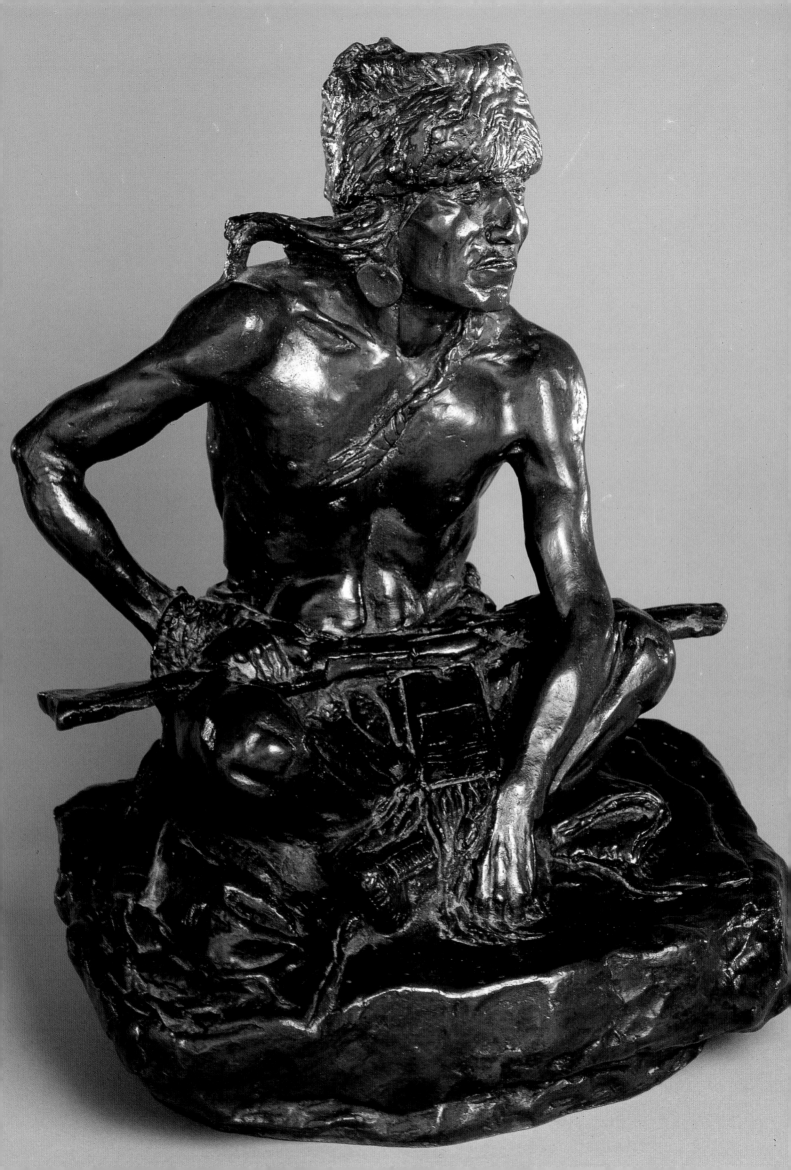

The Scalp

FREDERIC REMINGTON
*1898, bronze. Amon Carter
Museum, Fort Worth, Texas.*
Though the subject matter
may be unpleasant, this
dramatic piece met with
critical approval, one
authority declaring it
"a serious attempt to
express a moment's
energy by methods re-
poseful and dignified."

Watcher of the Plains

CHARLES M. RUSSELL

c. 1902, bronze. Buffalo Bill Historical Center, Cody, Wyoming.
Small at just 11 in. (28 cm) high, this dynamic piece readily
captures in the subject's tension the drama of the native scout,
always on the watch for the threat or promise of the unknown.

Friar Tuck

CHARLES M. RUSSELL

c. 1910, bronze. C. M. Russell Museum, Great Falls, Montana.

A remarkable divergence from the sculptor's usual western subject matter, this humorous piece was, perhaps, made as a gift or on special order.

Jim Bridger

CHARLES M. RUSSELL

1925, bronze. Buffalo Bill Historical Center, Cody, Wyoming.

Most spectacular of the fur trapping and trading mountain men, Bridger once appeared at an 1830s-era Green River rendezvous wearing a suit of steel armor! Russell captures him here in more prosaic dress.

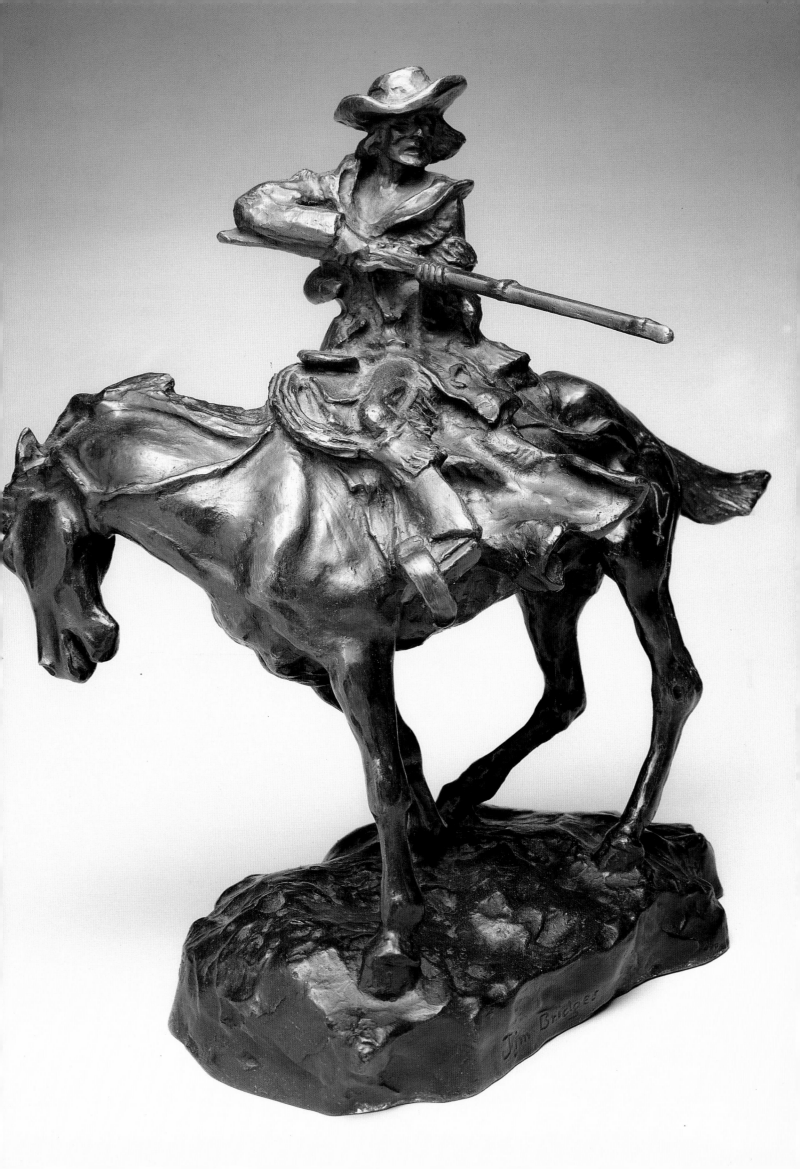

The Old Dragoons of 1850

FREDERIC REMINGTON

*1905, bronze. Remington Art
Museum, Ogdensburg, New York.*
While it is difficult to know just
who or where these precursors of
the western cavalry were fighting,
there is no denying the dynamic
and fluid composition of this work.

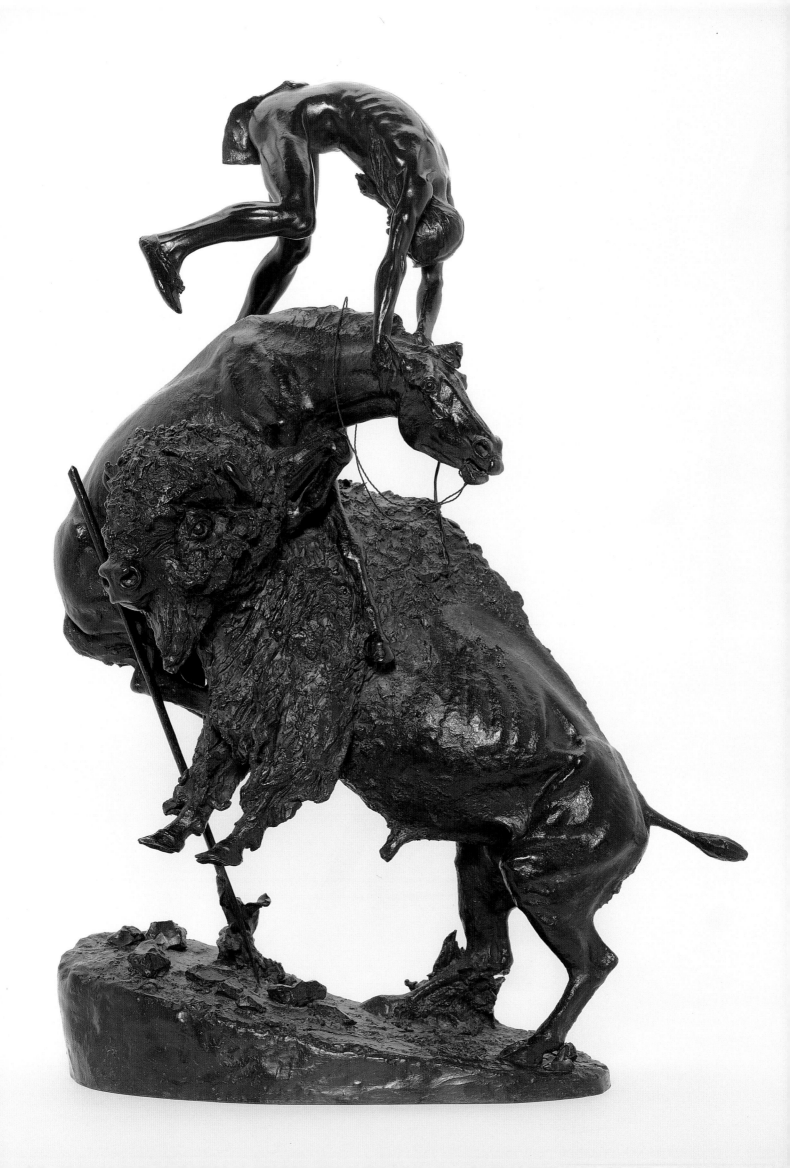

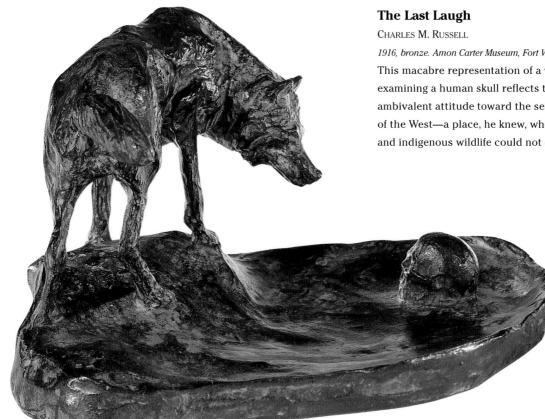

The Last Laugh

CHARLES M. RUSSELL

1916, bronze. Amon Carter Museum, Fort Worth, Texas.
This macabre representation of a wolf
examining a human skull reflects the artist's
ambivalent attitude toward the settlement
of the West—a place, he knew, where settlers
and indigenous wildlife could not coexist.

The Buffalo Horse

FREDERIC REMINGTON

1907, bronze. The Thomas Gilcrease Institute
of American History and Art, Tulsa, Oklahoma.
In this complex representation of man, horse,
and enraged bison, Remington skillfully
employs the Indian's weapon as a support for
the otherwise overburdened composition.

Bear on a Log

CHARLES M. RUSSELL

*1912, silver casting. C. M. Russell
Museum, Great Falls, Montana.*

Like many of Russell's sculptures
the small size of this piece (less
than 6 in. [15 cm high]) reflects
its origin in the miniature figures
he had made for years from
wax carried in his pocket.

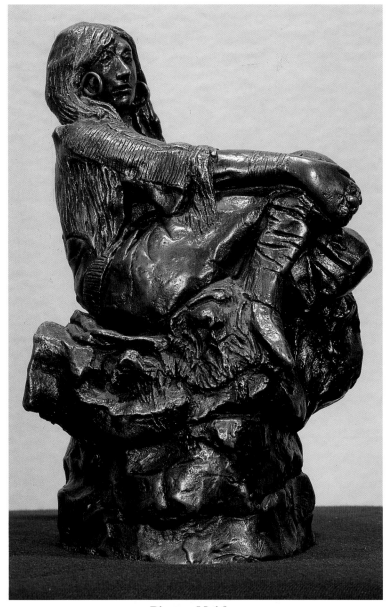

Piegan Maiden

CHARLES M. RUSSELL

1910, bronze. C. M. Russell Museum, Great Falls, Montana.

In this sensitive rendering of a Native
American woman, the figure seems to grow
organically out of the rock on which she sits.

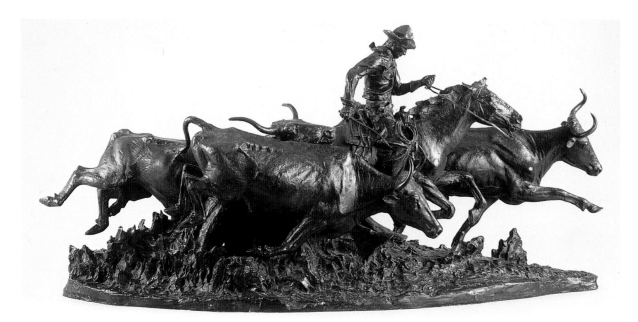

The Stampede

FREDERIC REMINGTON

1910, bronze. Remington Art Museum, Ogdensburg, New York.

This sculpture is a technically superior but strangely subdued depiction of that horrific moment when cattle run wild and cowhands risk their necks to get them back under control.

The Bronc Twister

CHARLES M. RUSSELL

1905, bronze. C. M. Russell Museum, Great Falls, Montana.

One of the artist's numerous studies of the horse in action, this sculpture is based on an earlier watercolor, *The Bucker* (1904).

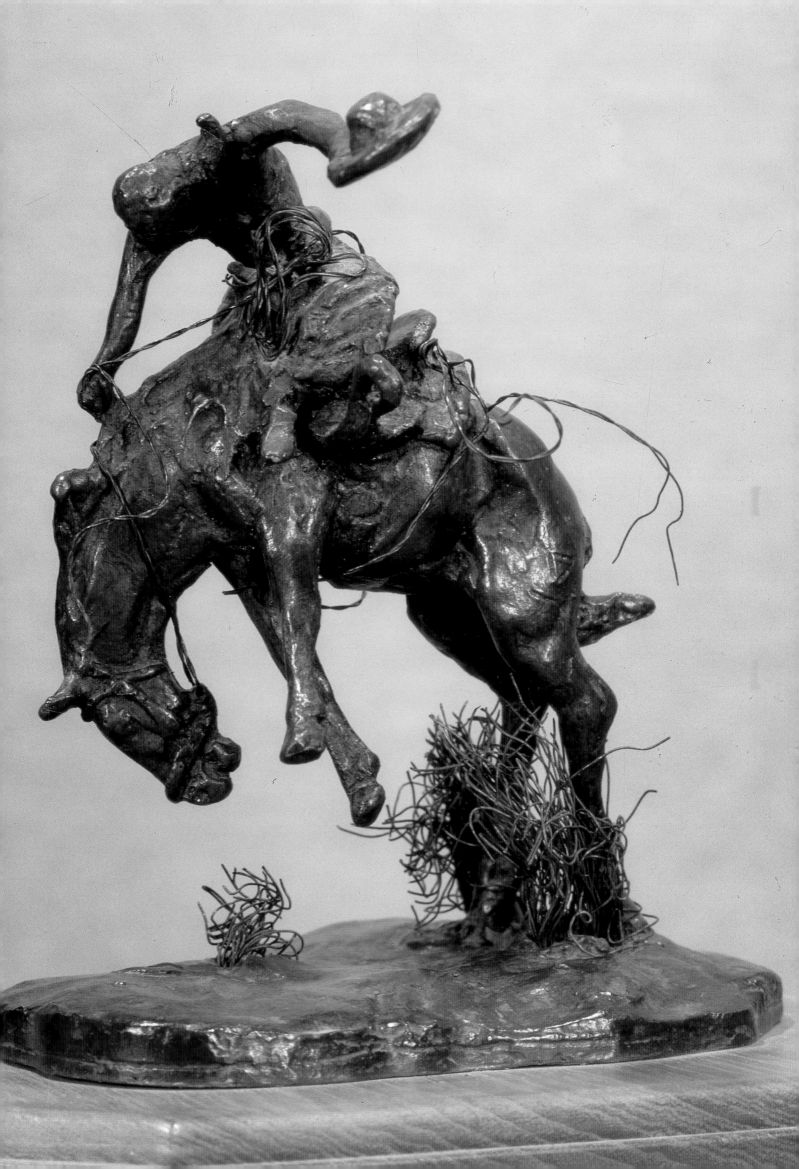

INDEX